# The Creative
# Drawing
## COURSE

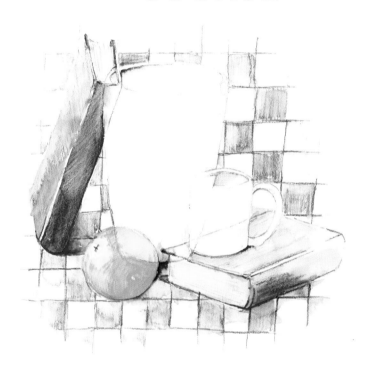

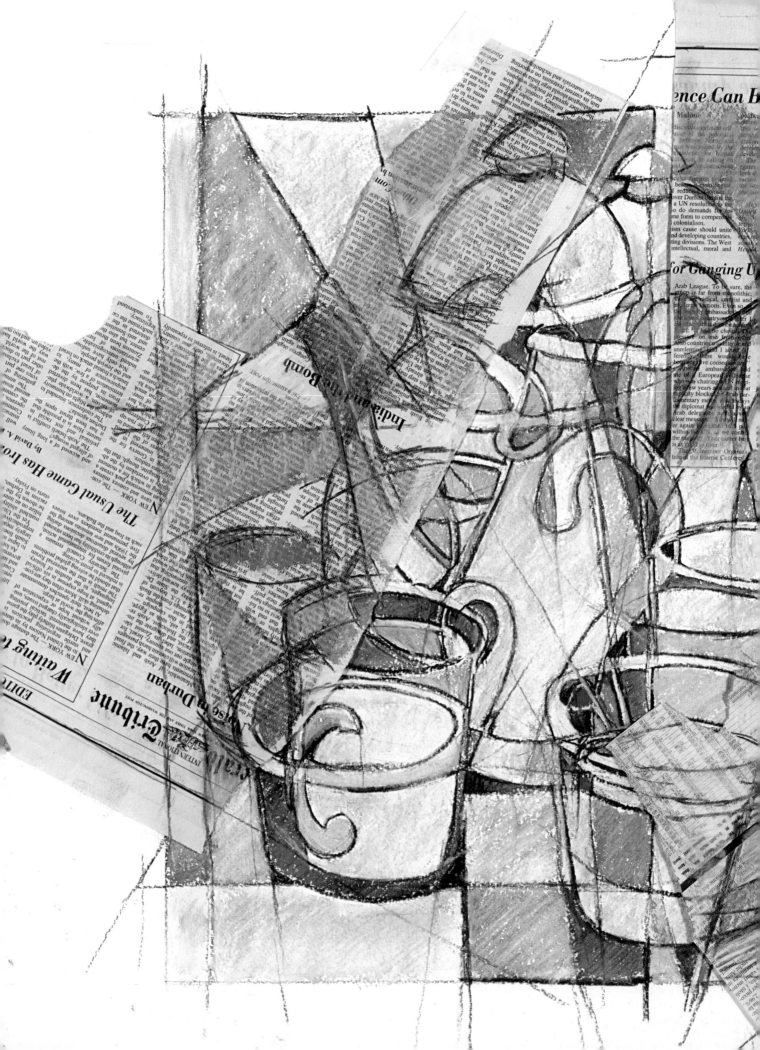

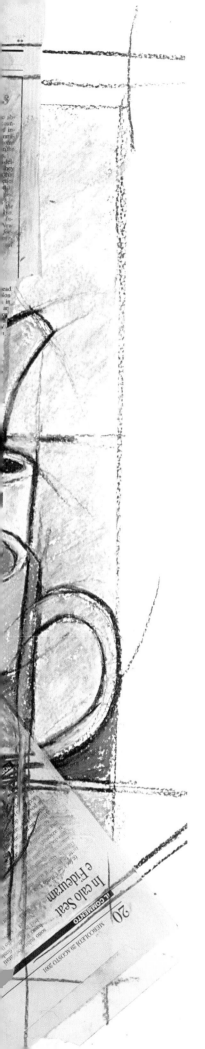

# The Creative
# Drawing
## COURSE

### Richard Taylor

David & Charles

A DAVID & CHARLES BOOK

First published in the UK in 2002

Copyright © Richard Taylor 2002

Richard Taylor has asserted his right to be identified as author of
this work in accordance with the Copyright, Designs and Patents Act, 1988.

A catalogue record for this book is available from the British Library.

ISBN 0 7153 1254 5 (hardback)
ISBN 0 7153 1449 1 (paperback)

Printed in Hong Kong by Dai Nippon Printing Co., Ltd.
for David & Charles
Brunel House     Newton Abbot     Devon

Commissioning Editor   Sarah Hoggett
Senior Editor   Freya Dangerfield
Production Controller   Kelly Smith

# CONTENTS

# Introduction

## Philosophy

The overriding theme of this book is simple – have a go! It is not much concerned with creating 'photoreal' drawings; instead, it focuses on your personal response to a subject, and to the creativity of the process of drawing.

I have deliberately selected everyday objects for the exercises so that you can practise in your own home. This approach also illustrates my belief that creative drawing relies more on your individual approach to a subject, however simple, than on elaborate, complex or surreal still-life set-ups.

## How this book works

This book is planned as a course, starting with the most accessible exercises and then working through to more complex ideas and projects.

The first chapter looks at the notion of observation and different ways of seeing and examining simple objects. Many of the practice exercises are followed by suggested 'extension' activities, which allow you to develop your skills further. This chapter also examines the concept that drawing need not be just about recording shapes on paper with a pencil. I encourage you to use as wide a range of materials as possible, using your fingers, hands and even water.

The second chapter introduces the idea of energy. Drawing is not always a passive exercise, undertaken sitting down. It can be very physical, and may involve stretching and whole-arm movements. For this reason there are 'warm-up' exercises at the beginning of some of the sections. This chapter also tempts you to try drawing onto a whole range of more challenging and experimental surfaces.

The third chapter encourages you to begin to draw directly, producing an instant response by utilizing the skills that you have gained from observation and energized drawing. The idea of being a slave to reality is discouraged here, as the exercises take on a more expressive and abstract nature. Why, for example, should you always draw a subject from one viewpoint? What do you see when you turn an everyday object upside down, or if you lie on your back to look up at something? A different viewpoint often creates a radical way of seeing your subject.

## Over to you

Throughout this book, I emphasize that drawing is a creative activity rather than a slavish copying exercise. I have chosen subjects that may not have obvious potential for drawings, and I discuss surfaces and combinations of materials that you may never have considered. But this innovation is the very nature of creativity – it is important to try something new and push back the boundaries of our experiences.

Throughout history, drawing has been used as a universal means of communication: people have drawn images with whatever they have to hand and on any surface available. I strongly urge you to do the same.

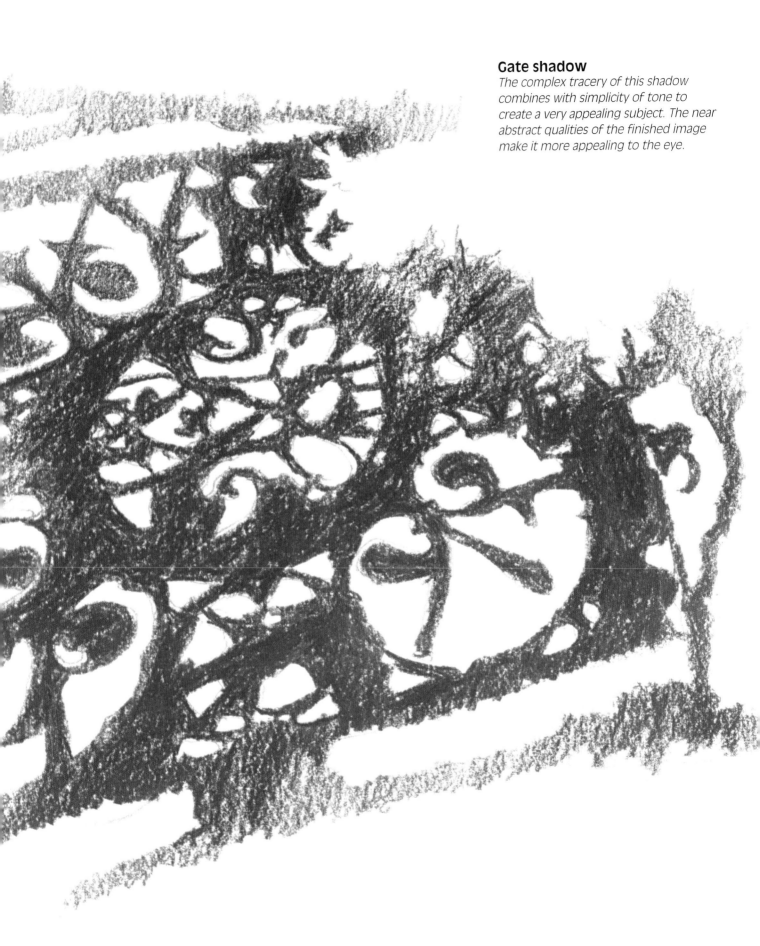

## Gate shadow

*The complex tracery of this shadow combines with simplicity of tone to create a very appealing subject. The near abstract qualities of the finished image make it more appealing to the eye.*

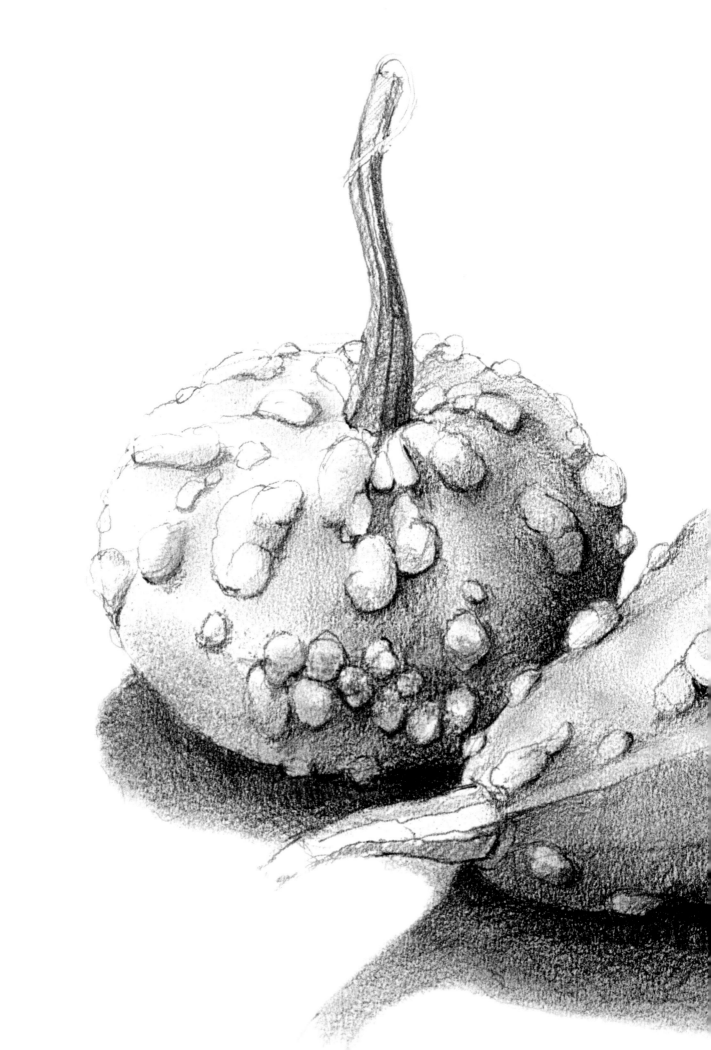

# DESCRIPTIVE DRAWING

Descriptive drawing is about finding ways of describing your subject. This usually means focusing on the subject's most dominant element: the linear qualities of a sea shell, for example, or the hard-edged shadows cast by a pile of books. Trying to include every aspect of your subject may result in a picture that overwhelms the viewer because of the jumble of information presented.

This chapter encourages you to develop your own visual shorthand, selecting the parts of the subject that you consider the most important. It will also open your eyes to a wide range of drawing materials and surfaces. You may not have considered drawing onto a postcard or envelopes, or drawing onto paper with a powder-covered finger, but these are valuable techniques for describing your visual world. Don't rule out anything! You will find that your choice of media and surfaces develops through experience and experiment.

**Describing texture**
*This drawing seeks to describe the textures of a pair of ornamental gourds, examining the way in which light bounces from the uneven surfaces.*

# What is line?

When artists talk about line, we mean creating a shape by enclosing it with a single line, or a series of lines. By using line alone to define a shape, the picture produced takes on a sense of design and pattern. With practice and close observation, patterns can be refined to create a three-dimensional image.

Lines can vary widely in appearance. They can be coloured or black; smooth and flowing or jagged and sharp; thick or thin; long or short; curved or straight. Whatever their appearance, the lines that we draw are a valuable vehicle for communication and expression. The exercises in this chapter will help you to train your hand to control the lines that you draw and to create a variety of effects with different types of lines.

### Simple outlines
*Most subjects will start with a simple outline, like this houseplant. Sometimes they need go no further.*

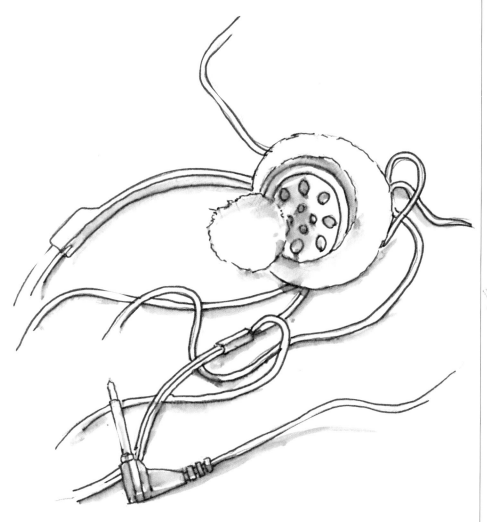

### Sinuous lines
*An old set of broken headphones provides scope for an interesting set of lines. The wires are sharply defined and create fascinating shapes as they twist and intertwine. The shadows were created by washing across the pen lines.*

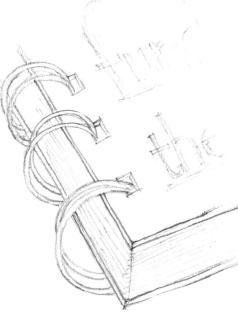

### Contrasting lines
*The corner of this ring-bound book offered a range of different types of lines, the sharp angles and straight lines of the book contrasting with the curved sweep of the binding.*

## Smooth drawing paper

*Drawing paper usually has a smooth surface and is therefore highly conducive to the making of fine lines. The dip pen used here allows you to create some variety of line by applying heavier pressure to the pen for thicker lines, or easing off for thinner, tapered lines. Too much pressure, however, can result in blobs of ink leaking out onto the paper. But don't think of these as spoiling your work – rather, regard them as additions or aids to texture.*

*Blots have a much softer edge on watercolour paper as the ink is absorbed slowly*

*Blots dry with a much harder edge on drawing paper*

*Scratchy surfaces can enhance the sense of texture*

## Hand-made paper

*The texture of hand-made papers makes them unsuited for most types of pen drawing, as the roughness of the surface prevents a free flow of ink, and the fibres often block the nib. Ink drawings made on this type of paper may feel laboured because of the amount of time it takes to create appropriate marks.*

## Rough watercolour paper

*The texture of watercolour paper tends to interrupt the free flow of a pen line, but not to the same extent as hand-made 'raised surface' papers. These papers usually create slightly ragged lines, rather than stilted or broken lines. However, they offer a lively surface to work on and are a little more challenging than smoother drawing paper.*

## Mark Making
### Pen and Ink

A variety of marks can be made with a pen (see below). Smooth lines can be combined with a stippling technique to suggest texture. Cross-hatching can be employed to create a greater sense of roughness.

# Hand-eye co-ordination

Drawing involves using first, our eyes to see, our brain to interpret the information received, and our hands to carry out the instructions sent to them. This is known as hand-eye co-ordination. The process of developing and refining your hand-eye co-ordination will come through frequent drawing, concentrating on following the directions of the lines in your subject.

The illustrations on this page are reproduced to scale to illustrate the span of the average hand movement. Many of the lines shown here were drawn in a single sweep, moving a pen across the paper while keeping the heel of the hand stationary on the paper surface. The exercises that follow are designed to encourage this type of practice while at the same time, improving your hand-eye co-ordination.

## Practice Exercise

This exercise will help to train your hand and your eye to work together. Find a shirt or piece of striped fabric, and drape it over the back of a chair so that you can clearly see the stripes change direction with the folds and creases. The key is to follow the lines and stripes of the shirt, allowing your eyes to be the guide throughout. Each time a stripe meets a fold and changes angle or direction, trust your eyes and follow their instructions faithfully. This requires concentration.

A fibre-tip pen is better than a pencil for this exercise because it helps you to learn when and where to stop lines. You can erase pencil lines, but pens are much more demanding and soon reveal your mistakes and hesitations.

**The starting point**
*A striped shirt carefully draped across a chair provides a set of lines to help practise hand-eye co-ordination.*

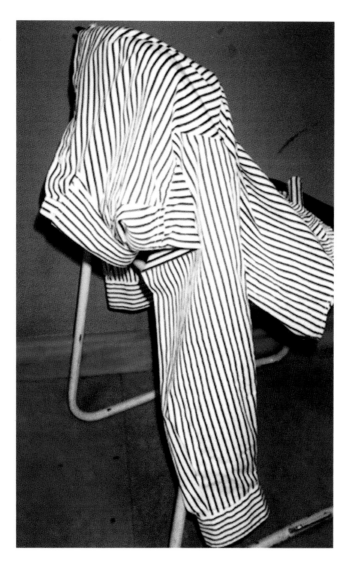

**1** To begin this exercise, half close your eyes to eliminate detail and focus on the main shapes. Keeping your hand still and moving only the fingers that hold the pen, draw a simplified 'block' version of the folds and creases, starting at the top of the page and pulling your pen in downward, sweeping strokes.

# Making Shadows

Shadows often help to 'anchor' an object, or group of objects, onto a flat surface. They also help to show exactly where the highlights will be, and will determine the strength of light cast on them. The other point to bear in mind when drawing shadows is that they are rarely black. Most shadows will hold the colour of the object that they are cast onto, and also will often reflect some of the colour from objects close by.

Soft media, such as pastels, charcoal and graphite powder, are all suited to conveying the blurred edges and subtle tones of cast shadows. Colour pastels can be overlaid and blended to reflect the colour of the object that they are cast onto.

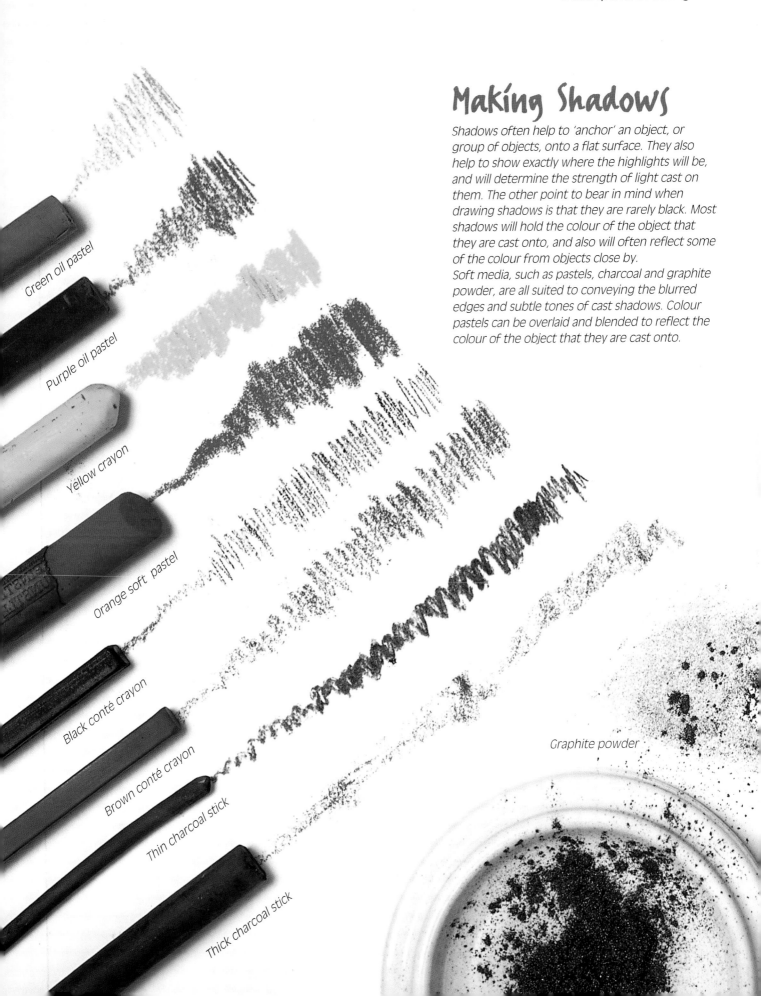

Green oil pastel

Purple oil pastel

Yellow crayon

Orange soft pastel

Black conté crayon

Brown conté crayon

Thin charcoal stick

Thick charcoal stick

Graphite powder

# Next Steps

Having practised creating hard-edged tones in pencil, experiment with different media and a variety of angles to explore their potential. Not all subjects are well suited to hard-edged tonal drawing, but a simple household object, such as a biscuit packet, makes a suitable subject with which to experiment.

### Textured tone

*The source of light here was at the front of the packet, but slightly off-centre, producing a shadow that could be clearly seen behind the packet. Using a 4B pencil, I experimented with cross-hatching (drawing one set of lines across another) to add some texture to the shadow.*

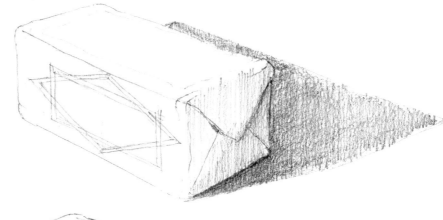

### Crisp-edged tone

*The light source was moved almost to the far edge of the packet to create the length of this shadow. I used a water-soluble graphite pencil to add a certain softness to hard-edged shadows, while maintaining the crispness of the edges.*

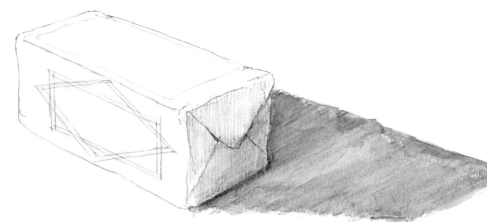

### Softening tone

*The packet was positioned in front of the light source to create this study. Even though the shadow had a clearly defined edge, it gradually softened towards the outer extremities. For this reason, I used graphite powder to create the shadows and shading.*

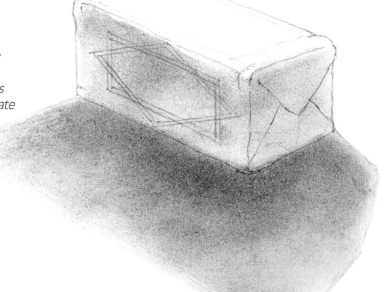

# Next Steps

You can develop the tonal range of shadows and shading in a drawing by introducing a colour and black and white. This range can be extended even further by the addition of an extra colour.

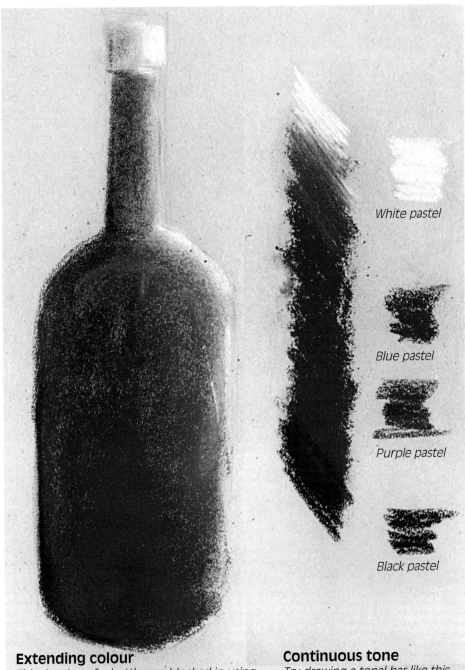

*White pastel*

*Blue pastel*

*Purple pastel*

*Black pastel*

**NOW TRY THIS**

Find a brightly coloured object and then draw it using just your fingers and graphite powder. Do not use a line drawing to start off with – work directly onto the paper. This will focus your mind entirely on tone without the safety net of an outline drawing.

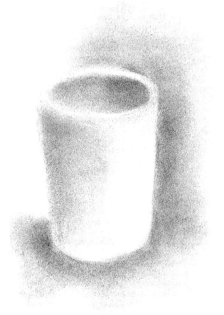

### Extending colour

*This drawing of a bottle was blocked in using one colour – blue. Its tonal range was then extended in the centre by blending in a bluish purple. The range was then pushed even further by the use of white for highlights and black for shadows.*

### Continuous tone

*Try drawing a tonal bar like this one, seeing how long you can make it without any obvious breaks in the tone. The more gradual the change in tone, the better.*

# Working outside a rectangle

Something that often inhibits our creativity when drawing is our tendency to view the end result within a rectangle, often with a neat space around the object. But it need not be this way! The purpose of this project is to let the subject dictate the final result, not the surface.

■ The objects here are all spherical. I was particularly interested in the way in which light and shade 'rolled' across the composition. With no hard, angular shapes in the group, I could practise graduated shading.

■ The next stage is to consider the shape created by the composition (in this case, an 'L' shape). Lay a few sheets of paper onto your drawing surface to copy this shape. Stick these sheets together at the back – most tapes are either slightly textured (such as masking

tape) or shiny (such as Sellotape), and interrupt the flow of your drawing if stuck at the front.

■ Now begin to draw, starting with the basic outlines of the group, and filling the sheets of paper. If, as with this drawing, the vigour of your marks requires the addition of an extra sheet or two to accommodate your extended lines, don't hesitate to add them.

■ Next, develop the tones by blending graphite powder, charcoal and pastels, working quickly across the paper to achieve a feeling of spontaneity.

■ The final stage is to draw quickly and freely with the points of charcoal, chalks, and pastel sticks, picking out highlights, establishing deep shadows, and introducing an element of colour to bring the whole scene to life.

*If part of the drawn image looks as if it will reach the edge of the paper, then add another sheet – don't let the shape of the surface control your drawing*

**NOW TRY THIS**

Try the exercise again, but this time use postcards. This enforces the new discipline of compressing and scaling down your shapes, and allows you to complete the drawing more rapidly.

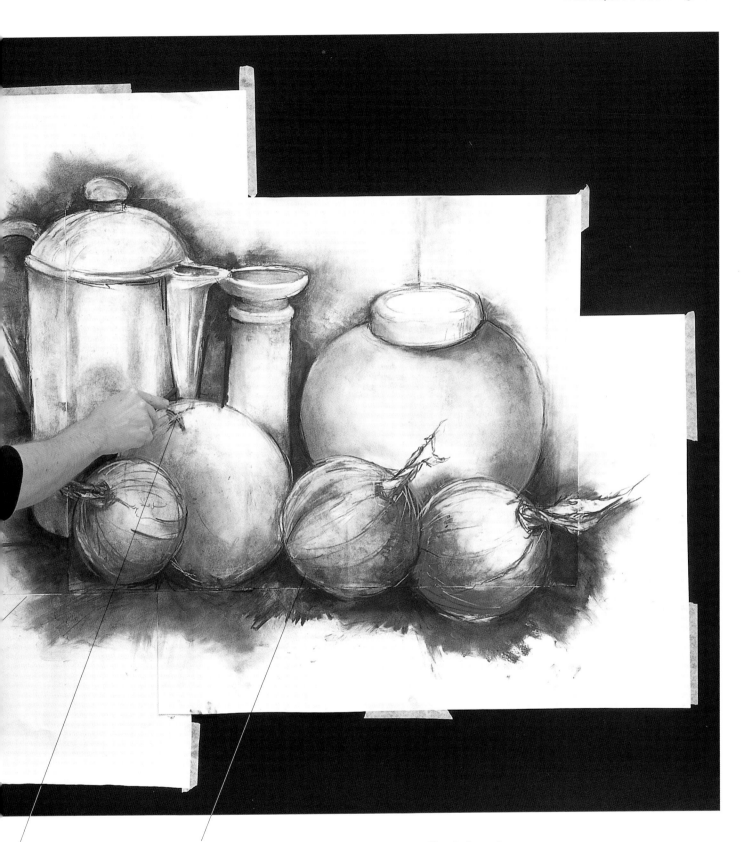

I used a wide range of mark-making techniques in this drawing, but the most visually exciting were the short, stabbing lines created with the tip of a stick of chalk

Sometimes even the smallest flash of colour in an otherwise grey drawing can make a picture really come alive

## The final drawing
The shape and size of this drawing's surface grew spontaneously during the course of its creation. I added extra sheets of paper as the image began to grow beyond its original size. The shape was organic, echoing the images being created and expanding to meet their demands.

# Measuring

If you want to create drawings with correct proportions, you need to learn to measure by eye. This involves comparing the component parts of a particular object, or assessing the size of one object in relation to another.

When you are first learning to measure, it is a good idea to use construction lines to help you compare sizes and shapes. At first your drawing will appear to be an irregular grid as you draw lines from one object to another in order to check and cross-refer its size and proportions. You can then gradually remove this safety net until you can assess just by eye the comparative sizes and shapes of the subjects that you are drawing.

## Practice Exercise

This exercise allows you to practise measuring the component parts of one object and ensuring that they fit together correctly.

A table lamp usually has two distinct sections: the base and the shade. These form one subject, but have different visual qualities to measure.

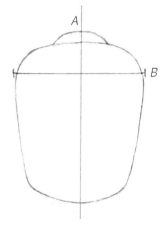

**1** Firstly, draw a vertical line (A). This will be the centre point of your subject, allowing you to judge the symmetry of the curves and the equal distance of both side lines. Next, draw a horizontal line (B) to represent the outer measurement (width) of the sides. Although it might not seem so at first glance, lines A and B are almost the same length.

**2** Hold your pencil at arm's length, line up the tip with the top of the shade and place your thumb at the point on your pencil where you see the base of the shade. Keep your thumb in this position and move your arm downwards to line up with the base of the lamp. Both measurements are the same – the height of the shade is the same as the height of the lamp base. So extend and double line A to give the height of the complete lamp. Now do the same with the width. The width of the lampshade is twice its height, so extend line B to its outer extremities and draw the lampshade. Just to check the positioning, extend a line (C) from the top of the diagonal line of the lampshade to the base of the lamp. This lines up the beginning of the top and bottom curves. Finally, check the measurement between the base of the shade and the top of the curve of the lamp (line D) to be quite sure that the spaces are as correctly proportioned as the shapes.

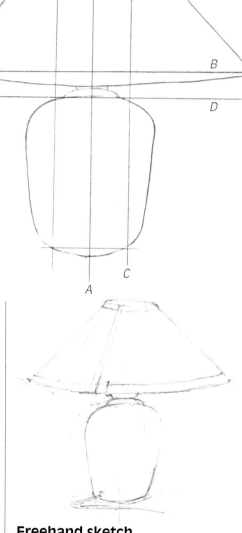

**Freehand sketch**
*Having worked through a drawing with measurement lines as a guide, try a quick freehand sketch of the same subject using only a centre line to guide you.*

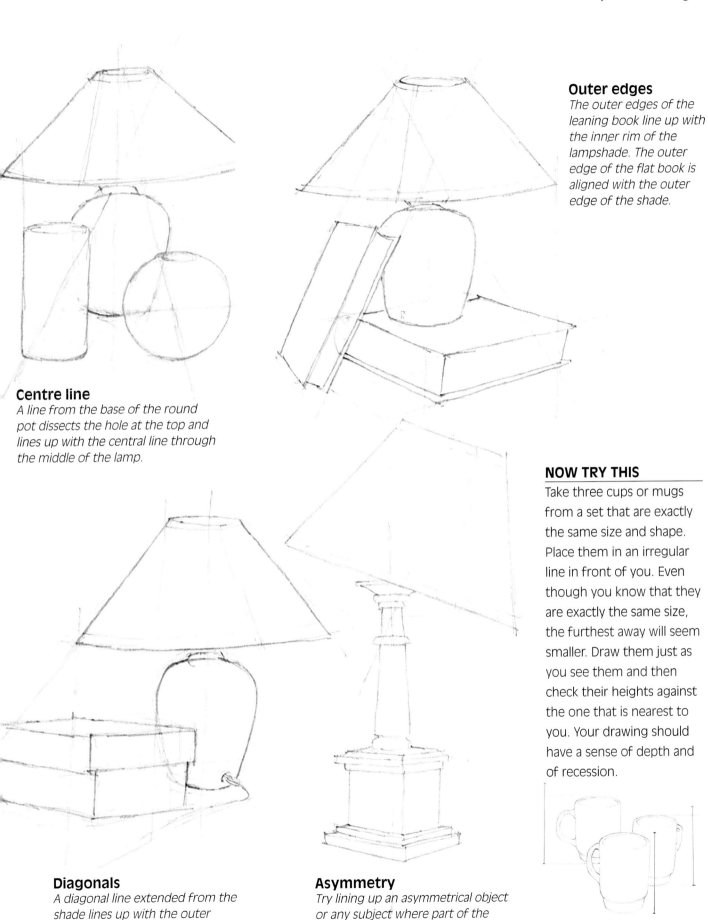

**Outer edges**
*The outer edges of the leaning book line up with the inner rim of the lampshade. The outer edge of the flat book is aligned with the outer edge of the shade.*

**Centre line**
*A line from the base of the round pot dissects the hole at the top and lines up with the central line through the middle of the lamp.*

**NOW TRY THIS**

Take three cups or mugs from a set that are exactly the same size and shape. Place them in an irregular line in front of you. Even though you know that they are exactly the same size, the furthest away will seem smaller. Draw them just as you see them and then check their heights against the one that is nearest to you. Your drawing should have a sense of depth and of recession.

**Diagonals**
*A diagonal line extended from the shade lines up with the outer edge of the box.*

**Asymmetry**
*Try lining up an asymmetrical object or any subject where part of the structure is off-centre.*

# Squaring up

Squaring up involves drawing a grid of squares or rectangles on top of a small drawing and then drawing the same number of squares, only considerably larger, onto the surface on which you wish to enlarge your drawing. The detail from the small squares or rectangles is then copied onto the larger squares or rectangles, ensuring a proportionally correct end result.

To avoid drawing directly onto your sketches, place a sheet of tracing paper over your work and draw a grid onto this. The grid should be large enough to cover all of the elements of the sketch you wish to enlarge. The disadvantage of this method of drawing is that the shapes may become a little fragmented as they are transferred. To compensate for this, you will need to stand back, look at the lines and shapes created when you have finished copying the contents of each square, and draw over them with a much looser freehand style.

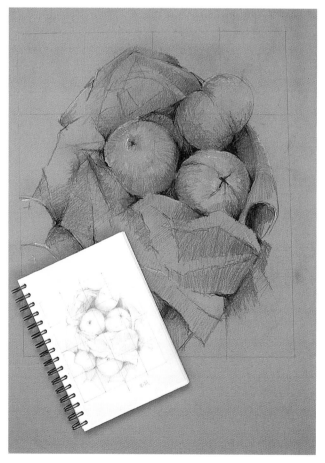

*You never know in advance if a sketchbook study will become a finished drawing. Squaring up can help you to take sketchbook studies that step further.*

## Practice Exercise

The aim of this exercise is to practise enlarging a small, quick sketch onto a considerably larger and differently textured sheet of paper. The small pencil sketch of some fruit in a folded-down, brown grocery bag was made in a small pocket sketchpad and enlarged (see opposite).

**1** Draw a square or rectangle around the section of your sketch that you want to enlarge. Draw a central perpendicular line and a central horizontal line, dividing the shape into four equal portions. Now do the same with these portions – divide them in half horizontally and vertically. You will now have sixteen equally sized shapes, creating a grid across your sketch.

**2** Measure the outer lines and multiply by three – thus a 12 x 14cm (4.5 x 5.5in) rectangle becomes 36 x 42cm (14 x 16.5in). Draw the new-sized rectangle onto the surface on which you wish to enlarge your drawing. You may wish to number the corresponding shapes on the grid.

**3** Now you can copy the lines and shapes from the grid that covers the sketch onto the enlarged grid, working one shape at a time.

**4** Finally, you may wish to rub out the grid lines before you start to develop the drawing, although some artists like to incorporate the lines into their finished pictures.

### NOW TRY THIS

Square up a drawing and incorporate the lines of the grid into the picture. Allow the sections of the grid to become important and vary the tones within each individual square or rectangle. You can create some dynamic visual effects by doing this.

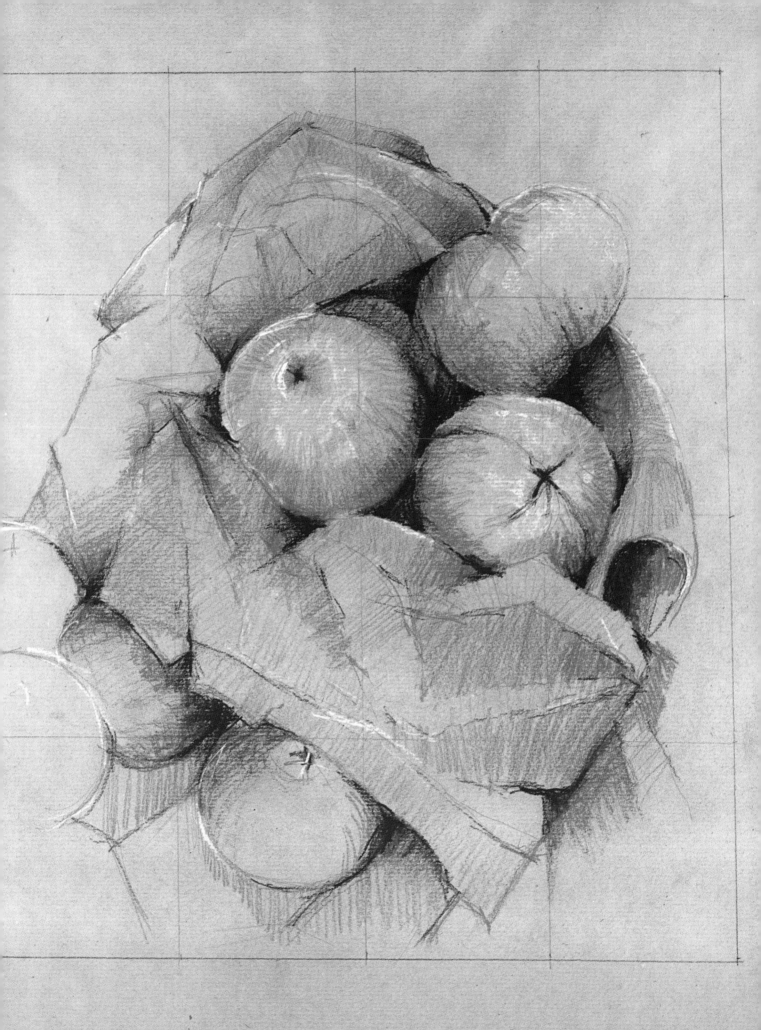

# Enlarging pictures beyond life-size

A large sheet of blank paper can be both exciting and intimidating, even to the most confident and experienced artist. Having practised making large drawings using a grid, try removing this safety net to experience the excitement of making a freehand drawing that renders your subject larger than its natural size. You need to take a very physical approach, which imposes a new discipline upon your drawing practice. Instead of just drawing with your hand, you need to use your entire arm, making sweeping strokes and stretching to extend lines across the paper. You may wish to do this standing at an easel or kneeling on the floor. Whatever you do, the drawing experience will feel very different.

## Practice Exercise

As this is such a different approach, you may wish to use a subject with which you are already familiar. This could be a small group of objects, or a sketch that you have already made. Here, I returned to a drawing of a tennis ball and bottle featuring a variety of graduated tones.

**1** Working onto a 59 x 84cm (23 x 33in) sheet of paper, take a stick of charcoal and in long, sweeping motions, mark in the shapes of the subject. As you do this, the charcoal will break and crumble; incorporate this into your drawing by smudging the fragments into the shape of the bottle. Use your whole hand, not just one finger.

**2** Now roughly block in the areas around the bottle and ball using vigorous, rapid marks. Smudge this with your hand, moving your arm across the paper to gain a feeling of movement with the drawing. The finished drawing contains a wealth of tones, energetically applied with a real feeling of power.

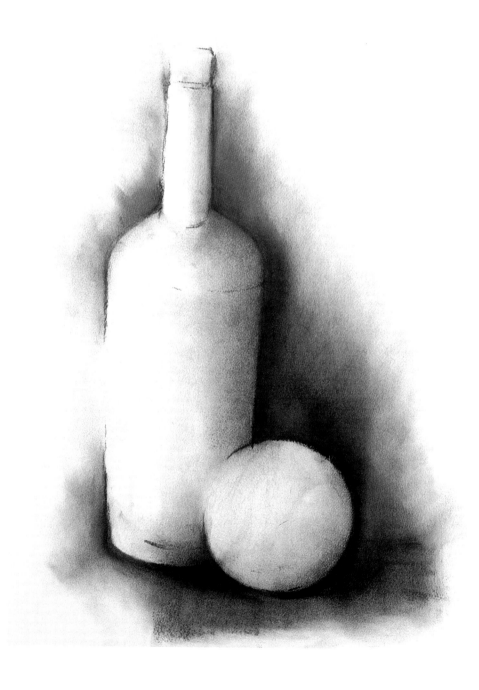

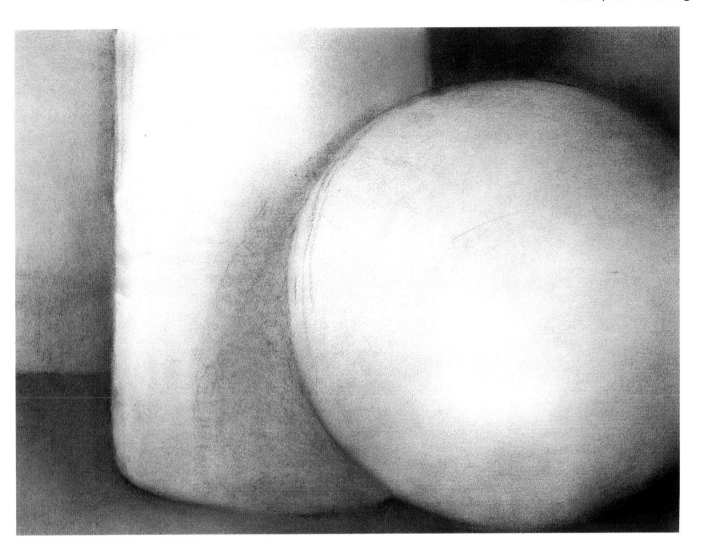

## Next Steps

Look carefully at the drawing that you have just created. It will be lively, and a little wild around the edges! Focus on one small section and enlarge that onto a 59 x 84cm (23 x 33in) sheet of paper (the same size as used for the previous exercise). The shading of this section will be even more physically demanding. You will need to work around the paper, from different positions, filling in large areas with a charcoal stick. The graduated shading on the ball will require you to work the charcoal dust with your hand in circular, sweeping motions, following the directions of the curves of the shapes. The end result will be a near-abstract picture with an extensive set of tones, shadows and highlights (see above).

## Mark Making
### Charcoal

Charcoal can be used for line drawing or for quick blocking-in of shapes. It is a crumbly medium, and you can use the powder to shade in part of your drawing. To achieve the best results, use the tip of a charcoal stick for strong shading, and the edge where softer toning is required.

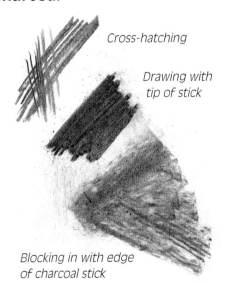

*Cross-hatching*

*Drawing with tip of stick*

*Blocking in with edge of charcoal stick*

# What is shape?

### Crinkled shapes

*The shapes found in this old leaf were a pleasure to draw as I needed to observe constantly the connections between the linear qualities and the way in which tone reacted to create a range of shapes. Each shift in tone almost created a new shape. The hard, angular shadows and tones served to enhance the crisp, sharp shapes of this simple subject.*

Shape is the vehicle by which we define our visual world. We tend to understand shapes more easily than we understand line or tone until we have the benefit of some visual education. As young children we are taught to recognize the most basic of shapes – circles, squares, triangles. From then on, we grow to look at shapes for recognition, assessing their exterior outlines and then seeking something to latch on to in the interior. We rarely look for the space created outside the shape. The more we draw, however, the more closely we observe the world around us and the more extensive our understanding of the key elements – line, tone, shape – becomes.

In this section of the course we will look at how lines and tone combine to create shapes, and at the different types of shapes. We will consider positive and negative shapes (the space created outside an object) and how one shape cannot exist in isolation.

### Branching shapes

*This study of some fronds of dried seaweed produced a fascinating selection of shapes. Tracing these as they overlaid each other, and creating new shapes in the process, was a rewarding exercise. The unusual, bulbous shapes and their gentle curves created a strange sense of light and dark as the natural light fell across them.*

# Positive and negative shapes

Seeing the shapes that lie in between objects is often just as important as seeing the shapes of the objects themselves. One set of shapes always defines the other. One decision you need to make when drawing is which set of shapes to emphasize to best effect – the positive or the negative ones.

A positive shape is the shape of an object itself – the legs of a chair or the bars of a window. Negative shapes are the areas in between the positive shapes – the spaces between the chair legs or the gaps between the bars. The positive shapes help us to recognize the subject of our drawings, whereas the negative shapes reinforce and give them definition. Looking into these negative shapes makes us focus upon the spatial relationships between the object and its surroundings without becoming distracted by the subject.

## Practice Exercise

This exercise encourages you to create a drawing in which both positive and negative shapes play an important role.

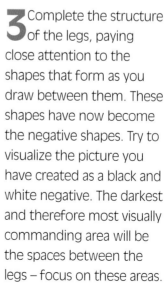

**1** Find a wooden stool and position it so that one of the legs is facing you. Try to see the entire stool contained within a crate and draw the three-sided box that this crate might look like. This will give you the outer shape of the stool.

**2** Draw the seat of the stool using the lines of the crate, and then mark in roughly where the wooden cross-bars fit in between the legs.

**3** Complete the structure of the legs, paying close attention to the shapes that form as you draw between them. These shapes have now become the negative shapes. Try to visualize the picture you have created as a black and white negative. The darkest and therefore most visually commanding area will be the spaces between the legs – focus on these areas.

**4** Now observe the shadows and tones visible when you look through the legs of the stool. By filling in these shapes, you give substance to the negative shapes, while creating a clearer definition of the stool itself. The shadows that are cast by the subject can help in this process of definition.

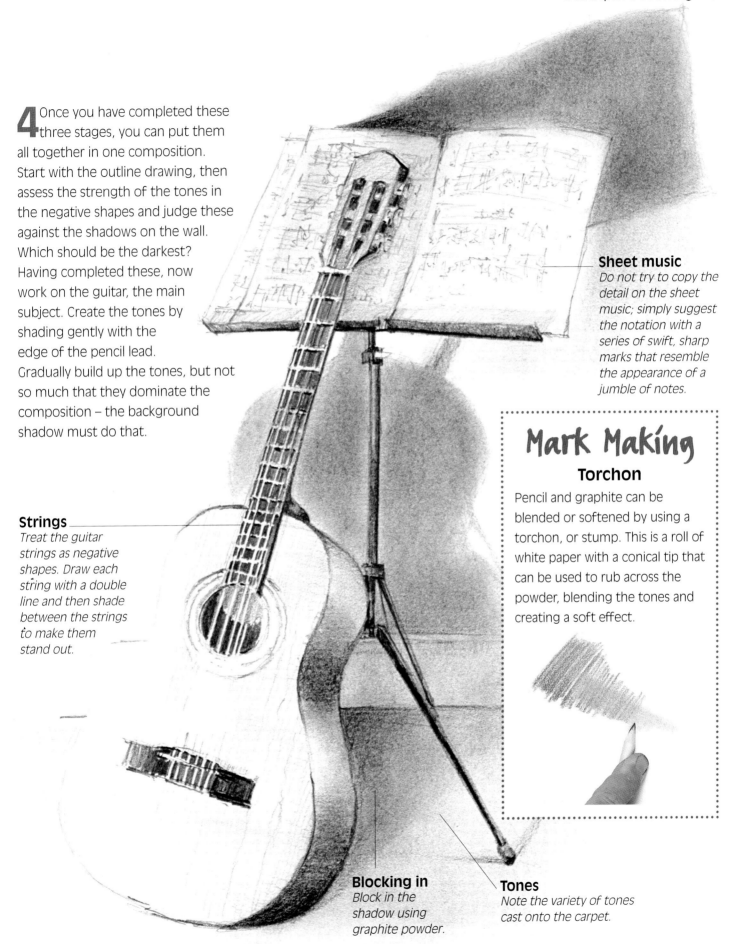

**4** Once you have completed these three stages, you can put them all together in one composition. Start with the outline drawing, then assess the strength of the tones in the negative shapes and judge these against the shadows on the wall. Which should be the darkest? Having completed these, now work on the guitar, the main subject. Create the tones by shading gently with the edge of the pencil lead. Gradually build up the tones, but not so much that they dominate the composition – the background shadow must do that.

**Sheet music**
*Do not try to copy the detail on the sheet music; simply suggest the notation with a series of swift, sharp marks that resemble the appearance of a jumble of notes.*

**Strings**
*Treat the guitar strings as negative shapes. Draw each string with a double line and then shade between the strings to make them stand out.*

# Mark Making
## Torchon

Pencil and graphite can be blended or softened by using a torchon, or stump. This is a roll of white paper with a conical tip that can be used to rub across the powder, blending the tones and creating a soft effect.

**Blocking in**
*Block in the shadow using graphite powder.*

**Tones**
*Note the variety of tones cast onto the carpet.*

# Shadows and structure

This late afternoon scene had an instant appeal. The long, warm shadows cast through the ornate wrought-iron stairway by a low sun created a fascinating mixture of shape, tone, light and dark, all fitting together to form a visually dynamic composition.

The wonderful shapes created by the shadows acted as a backdrop for the complex tracery of the railings, visually thrusting them forward. All in all, it was a subject that could not be ignored.

**The starting point**

*The sight of these shadows caught me by surprise. I had no drawing equipment at the time, but I did have a camera so was able to record the striking shadows for later.*

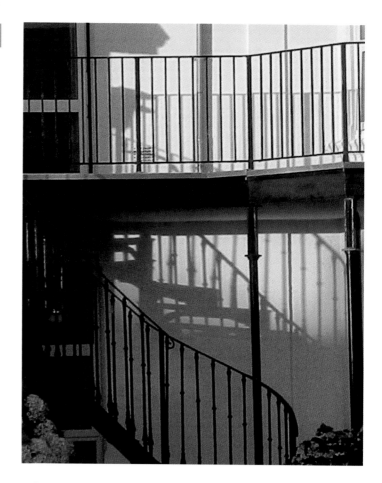

**1** The first stage of this drawing was to map out all of the shapes, both positive and negative. Using a 2B pencil, I drew the wrought-iron staircase and railings. Then, looking closely at the shadows created by these, I drew the outlines of the shapes visible through the metal grid.

**2** Using graphite powder, I began to block in the shadow shapes, rubbing the powder evenly into the fibres of the paper. For practical purposes, I started at the top of the paper and moved down towards the bottom to ensure that I did not smudge areas as I worked.

**3** The small railings were particularly difficult to fill in with graphite powder as they were considerably less than a finger's width, so I used a cotton bud. These buds can be used for both blending and manipulating graphite, pulling and pushing it into small spaces where fingers would be too large and clumsy.

**4** Any stray graphite powder that had become smudged into the highlight sections, I gently removed with the point of a kneaded eraser.

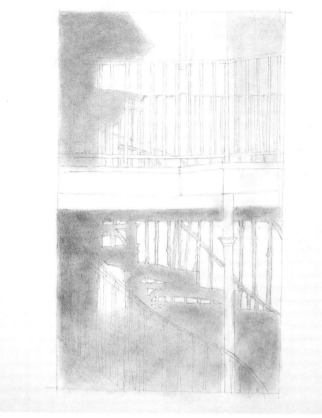

**6** Having established an undercoat, the next stage was to develop the range of tones observed in the shadows. To start this process, I used a stick of thin willow charcoal. This enabled me to draw in between the railings, creating a negative grid.

**5** I then sprayed the drawing with fixative to prevent any more smudging of the graphite undercoat as I continued to work over the picture surface.

**7** I then blended the charcoal onto the graphite, creating a graduated appearance and varying the quality of the dark and medium tones. I sprayed this stage of the drawing with fixative to prevent it from smudging during the next stage.

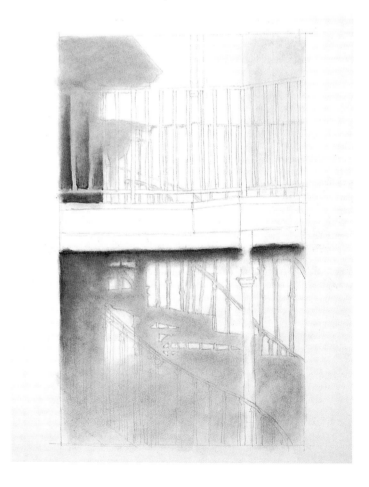

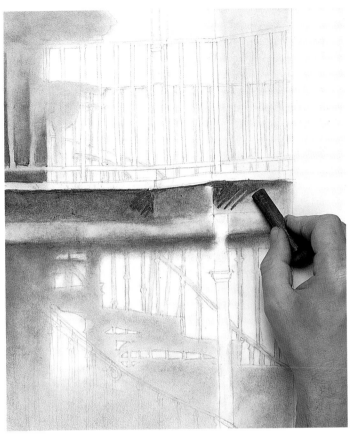

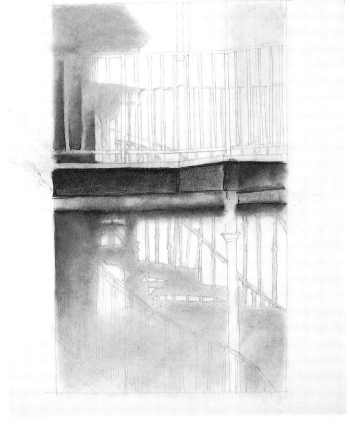

**8** Having established both the shape and the tones of the shadows, I moved on to the metal structures that created the light and dark in the picture. I drew the main balcony with a large stick of willow charcoal – this medium gave maximum coverage.

**9** I took care at this stage to ensure an even distribution of light and shade, especially when slight angles in the metal structure created a variation in tone.

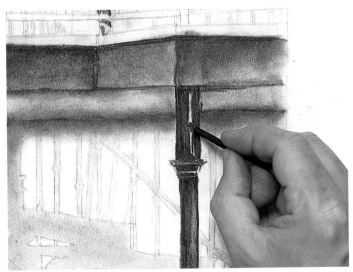

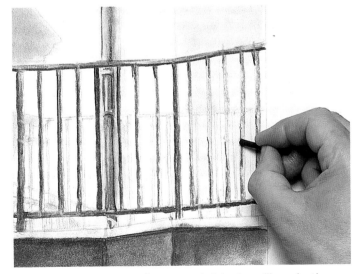

**10** To draw the supporting pillar, I used the small stick of charcoal to create long, vertical strokes. To ensure that this looked curved, I left a few flashes of white paper showing to suggest light bouncing from the round metal surface.

**11** I drew the smaller, more intricate railings in the same way, ensuring that, wherever possible, a few small flashes of bare paper were left to suggest highlights bouncing from painted metal.

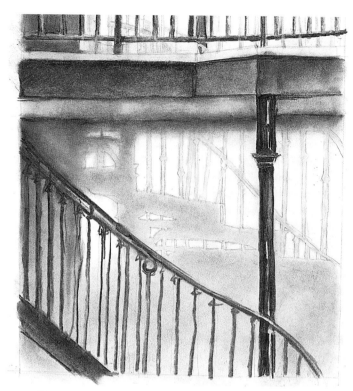

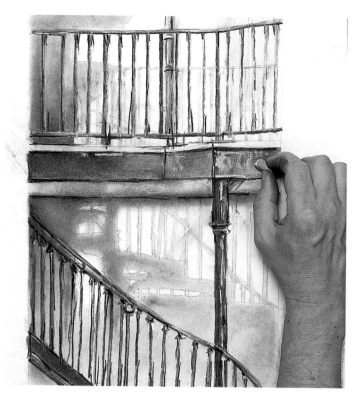

**12** Once I had drawn the handrails on the lower staircase in the same way, the drawing was nearly finished. This is the time to physically stand back from your work and assess the balance of the tonal values. Observe whether the lights are bright enough, the darks black enough, and the mid-tones graduated enough.

**13** I decided that the appearance of light and shade could be sharpened up by the addition of a few carefully placed white chalk marks, chiefly along the edges of handrails and railings where the white paper had become covered with charcoal and graphite. Finally, I applied a little more graphite powder to the bottom right of the drawing to balance the composition. I then sprayed the drawing with fixative, and declared it complete.

# Mark Making

## Graphite Powder and Chalk

The chief forms of mark making used in this drawing were (A) smudging graphite powder, (B) manipulating graphite powder with a cotton bud, (C) blending charcoal onto fixed graphite powder, and (D) using quick, confident chalk marks to suggest highlights.

*A*

*B*

*C*

*D*

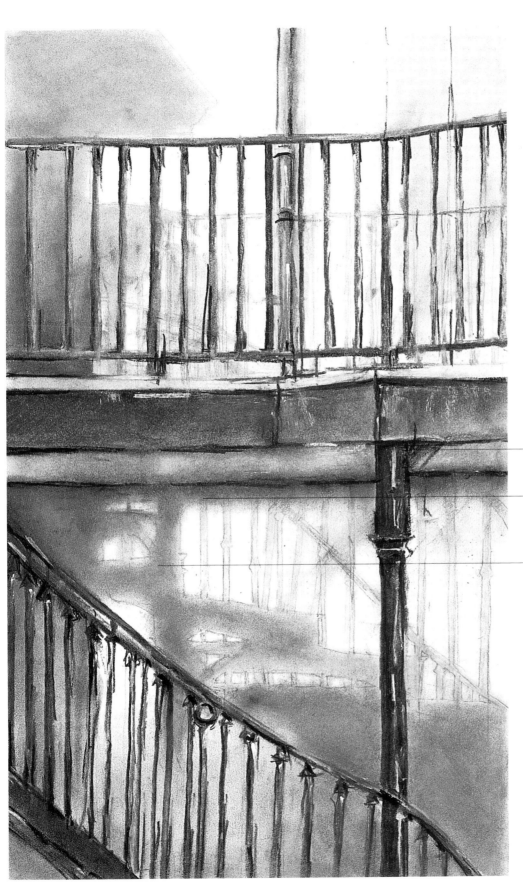

**The finished drawing**
*This drawing worked particularly well because of the variety of tones used – both strong and subtle – and the series of abstract shapes created in the process.*

*Sharp highlights created by applying flashes of chalk*

*Soft shading used as a backdrop against which to view the hard lines*

*Intricate pattern created by shadows adds to the complexity of the drawing*

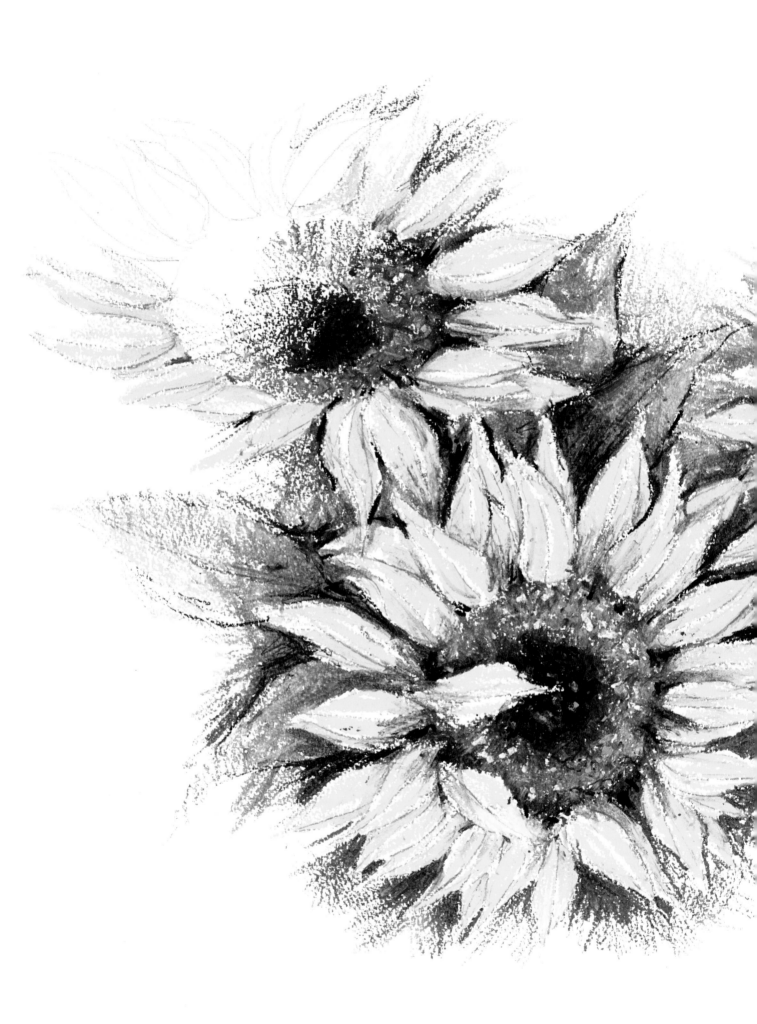

# ENERGIZED DRAWING

The aim of this chapter is to shift the concept of drawing away from pure observation, and to consider how we approach the act of drawing. Many of the exercises in this chapter require you to make a rapid, spontaneous response to a subject. 'Energized' seems an appropriate term for the techniques described here, because of the speed required to manipulate the media and the scale of the surfaces used.

Two types of energy are explored in the following exercises. The first is visual energy. This means the ability to seize on a potential subject for a picture, spotting the image and responding to it immediately, rather than spending a long time setting up a group of objects to draw. The second type of energy is physical energy. You will find that drawing can be a very physical act that involves moving more than just your hand. You might need to use your whole arm to take a line in a long, curving stretch, or to stab at a surface to create a textured image. Both types of energy produce lively drawings that contain abundant energy of their own.

**Exciting colours**
*Concentrating on just the colours and shapes of these sunflower heads allowed me to adopt a much more energized approach to drawing them.*

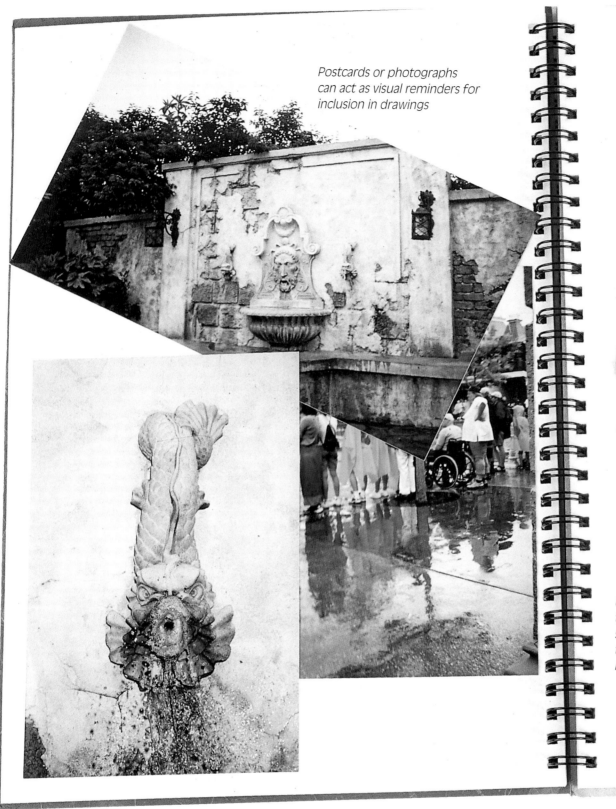

*Postcards or photographs can act as visual reminders for inclusion in drawings*

*Anything can be used in a sketchbook to remind you of shapes or colours that you may wish to remember*

### Taking notes

*Sketchbooks act as visual mementos for artists, and we can dictate our notes in many different ways. Drawing need not be the only component – photographs, postcards and other types of visual reminder are also valuable.*

## Practice Exercise 2

This exercise allows you to practise creating lines by drawing primarily with the tips of pastels.

**1** Draw the overall shape with an olive green oil pastel, using the tip to follow the lines.

**2** Pick out the darker lines or areas of shadow using the tip of a black oil pastel and reinforce this with a blue-green pastel.

**3** Now use yellow and green chalk pastels to draw the highlights. The hard edge of the chalk pastels cuts through the greasy surface of the oil pastel, allowing the highlights to show through.

### The finished drawing
*This freshly picked corn cob, with its tightly packed leaves, had interesting linear qualities that made it an ideal subject for rapid blending.*

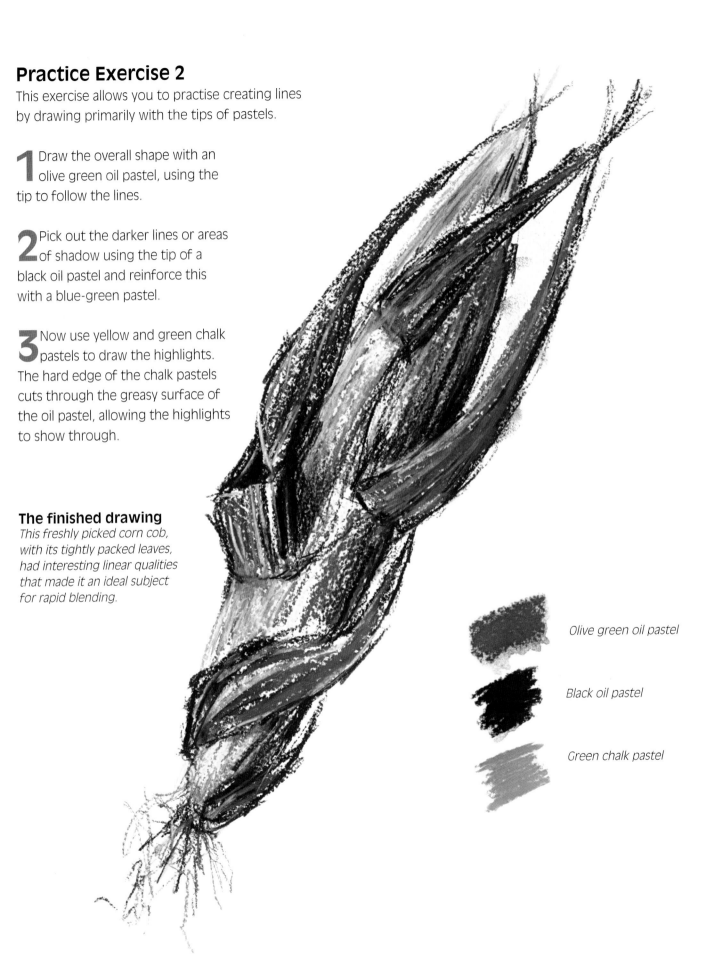

*Olive green oil pastel*

*Black oil pastel*

*Green chalk pastel*

# Texturing surfaces

Drawing highly textured subjects can be more successful if your drawing already has an established visual texture, such as a speckled surface, or a set of pre-printed cross-hatched lines. A tactile texture, such as those found in hand-made papers, is not usually so effective, so you will usually have to create the surface for yourself. This can involve flicking or spraying paint, sprinkling pigment, or rubbing crumbly sticks, such as pastel, across a surface with some tooth to hold the pigments in place. You may well have to wait for your surface to settle or dry, but it will be worth it. This approach can be very expressive, allowing you to experiment with abstract shapes.

## Practice Exercise

As you will rarely find papers with a visual texture in art stores, you will need to create your own. One simple way of doing this is described below. Watercolour paper is the most appropriate surface for this exercise, as it is designed to absorb water gradually.

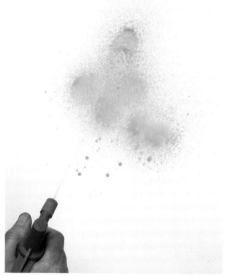

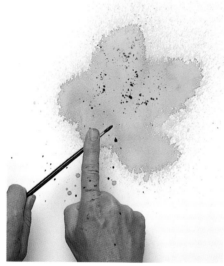

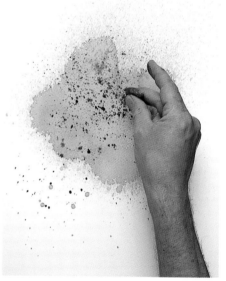

**1** Place a sheet of 300gsm (140lb) watercolour paper on a flat surface. Fill a mist spray-gun one-quarter full with water and add drops of liquid watercolour (these are similar to inks and can be purchased in small glass jars with droppers) until you achieve the colour or tone you want. Spray the diluted paint onto the paper using several short bursts: this technique prevents an even coating of sprayed paint on the paper.

**2** When the sprayed paint has dried, dip an old paintbrush into another colour of watercolour paint. Holding the brush directly over the paper, tap the ferrule vigorously. This sends tiny specks of paint spattering across the paper surface, increasing the textural effect of the paint previously sprayed. Wait until the first paint has dried, or you will create a blended colour rather than a speckled texture.

**3** To add even more tiny textured speckles, sprinkle some graphite powder unevenly over the surface of the paper. Fix it with a fixative spray to prevent smudging. This enhances the visual texture and creates a piece of paper that is much more exciting to draw on than a plain sheet.

## Next Steps

Terracotta pots are an ideal subject for practising drawing on patterned paper as their textural qualities complement this technique particularly well.

### Enhancing texture

*Pastel drawn onto a patterned or spattered surface crumbles and, when rubbed onto the paper, allows the colours or spatters underneath to show through.*

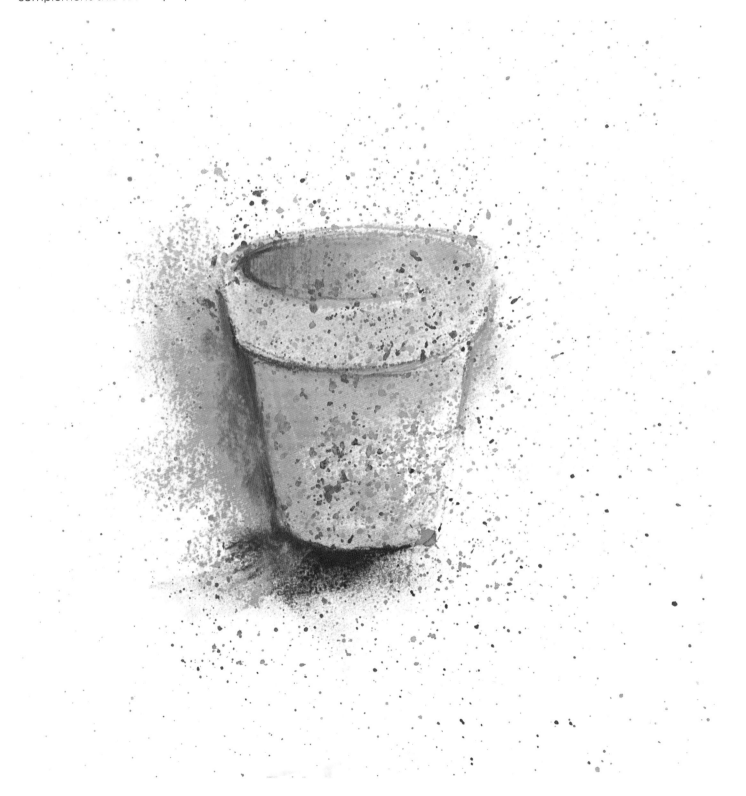

# Patterns in unusual places

Almost any environment can yield an unending supply of subjects to draw – all you have to do is look for them! With this in mind, I set about scouring the seafront near my home for subjects such as driftwood and shells. Ironically, I found the most exciting subject when I turned my back to the sea and spotted this crack in the sea wall. The organic shape of the crack, and the textures of the stone, gravel and concrete surrounding it, proved irresistible.

The wall was a complex subject and required some thought as to how to record it. In order to make the visual dynamics fully effective, I decided to simplify the subject: a cluttered drawing with too many details would spoil the simplicity and clarity of the sharp lines.

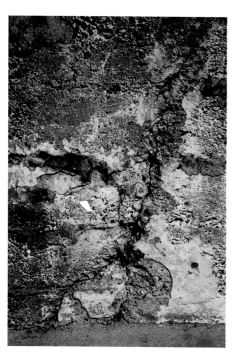

**Fascinating patterns**
*I took this photograph to remind me of the details of the wall's cracks and fissures once I had returned to the studio.*

**1** My first stage was to focus on the elements of the subject that first caught my attention: the depth and sharpness of the central crack; the irregular patterns that ran along its length; and the contrast between the small and large shapes created by the displaced plaster. Once I had decided what to include, I made a line drawing. I used a combination of long lines stretching across the paper and short, sharp lines.

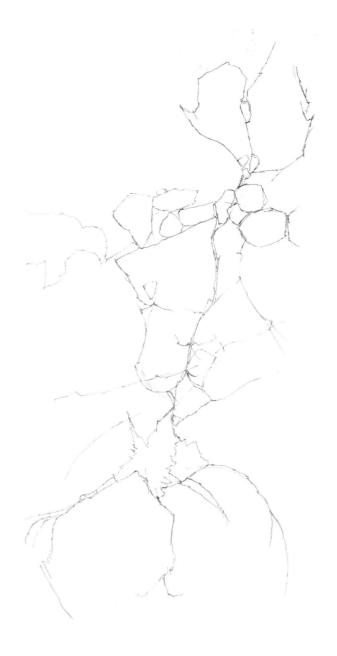

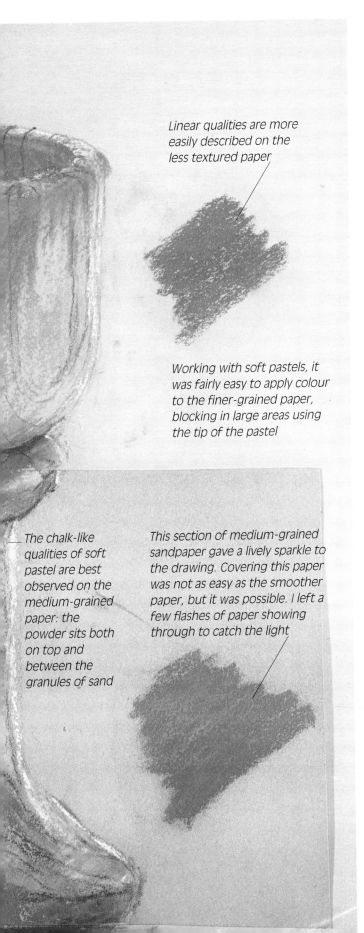

Linear qualities are more easily described on the less textured paper

Working with soft pastels, it was fairly easy to apply colour to the finer-grained paper, blocking in large areas using the tip of the pastel

The chalk-like qualities of soft pastel are best observed on the medium-grained paper: the powder sits both on top and between the granules of sand

This section of medium-grained sandpaper gave a lively sparkle to the drawing. Covering this paper was not as easy as the smoother paper, but it was possible. I left a few flashes of paper showing through to catch the light

### Varied textures

*Working on composite paper can be fun as you are drawing onto several different textures within one picture. This means that a single line drawn over different textures develops different qualities.*

## Next Steps

Highly textured wallpaper is another challenging surface to experiment with. The wallpaper used for the drawing below was so textured that it was difficult to draw any type of line. Also, the powder from the two Conté crayons that I used sat on top of the raised surface, making it difficult to maintain the drawing: any movement or draught blew the powder off the paper. I needed to use a lot of pressure and a vigorous drawing style to create an image, and I had to spray the drawing frequently with fixative.

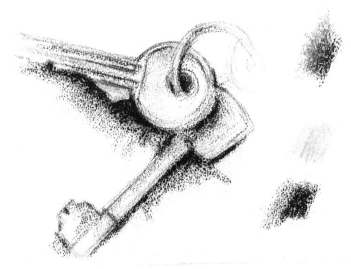

### A challenging surface

*Drawing on this highly textured surface was certainly challenging. The end result, however, is a lively drawing with a grainy appearance and a deep, rich black tone.*

# Using strong colours

The starting point for this drawing was a collection of coloured sweet wrappers – some whole, some torn, some flat – that I dropped onto a flat surface and secured as they fell.

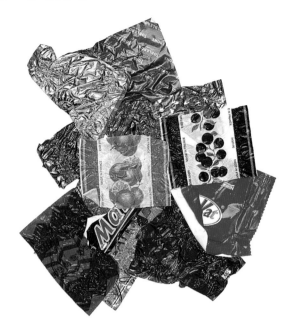

**The starting point**
*The random nature of this group of coloured papers was particularly appealing, as it freed me to impose my own discipline upon the subject. I could therefore focus on the areas that I felt would make a good, visually balanced composition.*

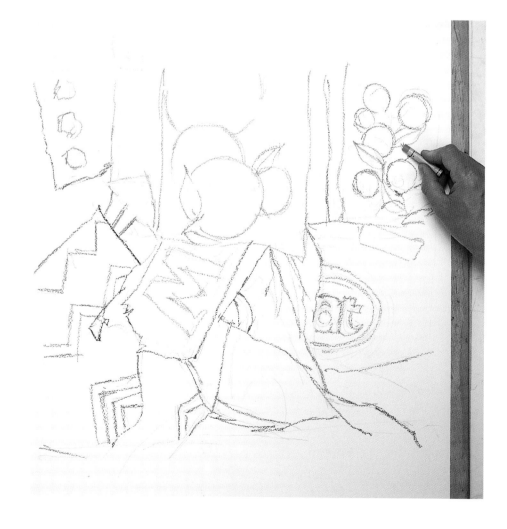

**1** I quickly sketched the wrappers on a large sheet of paper. I used confident marks, stretching across the paper to achieve long lines, rather than making tentative and hesitant shapes. I used the appropriate colour pastels for each wrapper, working vigorously even at this early stage.

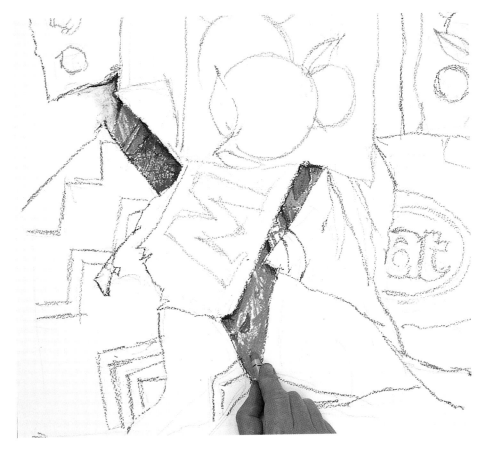

**2** I worked on some of the smallest detailed areas first in order to create a central section from which to expand outwards. This technique creates more visual energy in a drawing than working from side to side, or from top to bottom.

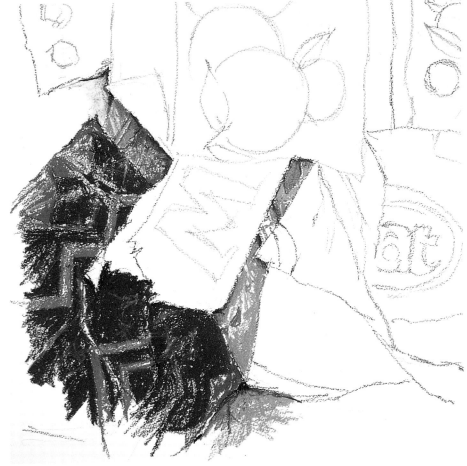

**3** The natural extension of this area was the bottom left-hand corner. I drew the shadows cast in the creases in the wrapper with a simple black line. For the deeper shadows, I worked black pastel on top of the existing colour, suggesting a level of graduated tone. The tops of the creases – the highlights – I created with flashes of pure white pastel.

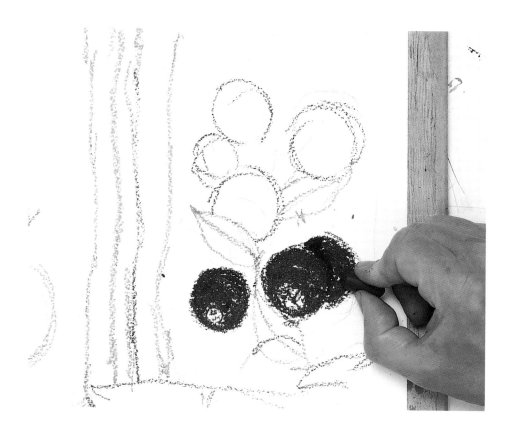

**4** I then drew the round, berry shapes of the wrapper design. I left a small circular section of the berry shape to act as a highlight (the paper was not as light as the white pastel used to create reflected light) and worked around the outer edge in black to create a contrast.

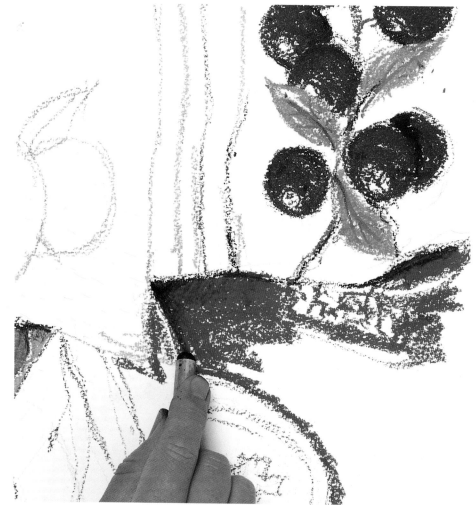

**5** The scale of this drawing meant that I did not have to worry about creating creases and folds with carefully placed, delicate marks. I could afford to work the black pastel on top of the red, using vigorous marks, while leaving the white paper untouched to suggest the top of the crease.

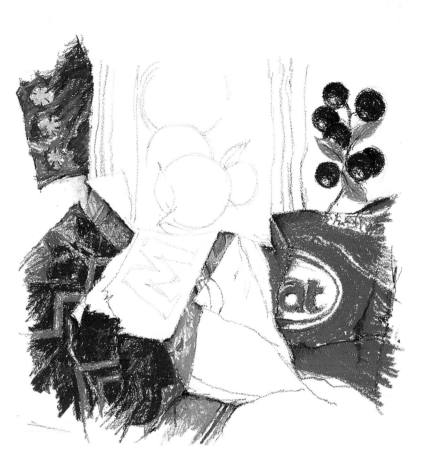

**6** Continuing to work in an expanding circle, I was beginning to visually sandwich the central areas of the composition. When using this technique to create an energized drawing, make sure that the marks do not all go in the same direction. The lines drawn so far in this demonstration all lead the viewer's eye into the centre of the design, but they come from many different directions. This, combined with the lack of finish at the outer edges, contributes greatly to the energy of the finished picture.

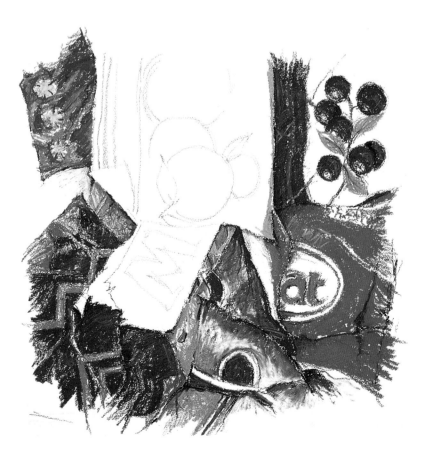

**7** Until this stage of the drawing, I had used mainly pure colours. I had needed to darken these a little to produce shadows and shading. The next set of wrappers, however, required the addition of white to lighten them. To achieve this, I drew the main colour onto the shape and worked over it with the tip of a white pastel.

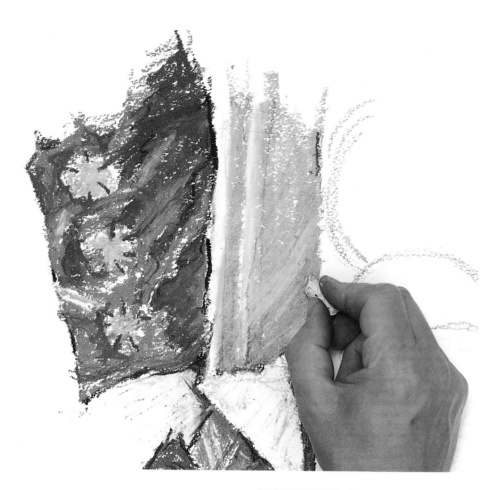

**8** The orange wrapper at the top of the drawing required similar treatment. To create the natural highlights where the light reflected from the shiny paper, I applied much more pressure to the white pastel. The build-up of the greasy layers of pigment from the oil pastels effectively suggested reflected light.

**9** The orange shapes were created in a similar way to the blackcurrants, but this time I used two colours. The initial application of orange pastel, in a circular motion, created a natural highlight. I worked around the outside of the shape and eased off the pressure towards the centre. I then worked over the outer orange with a red pastel, reinforcing the sense of shape.

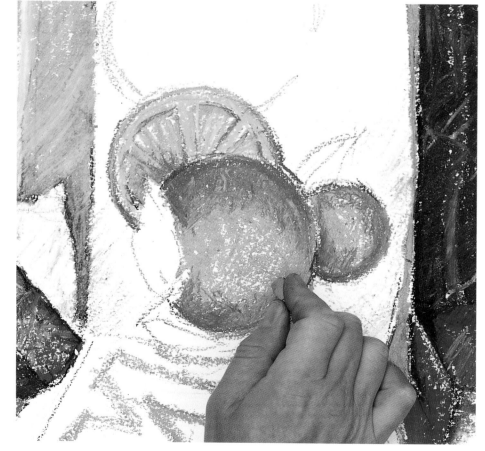

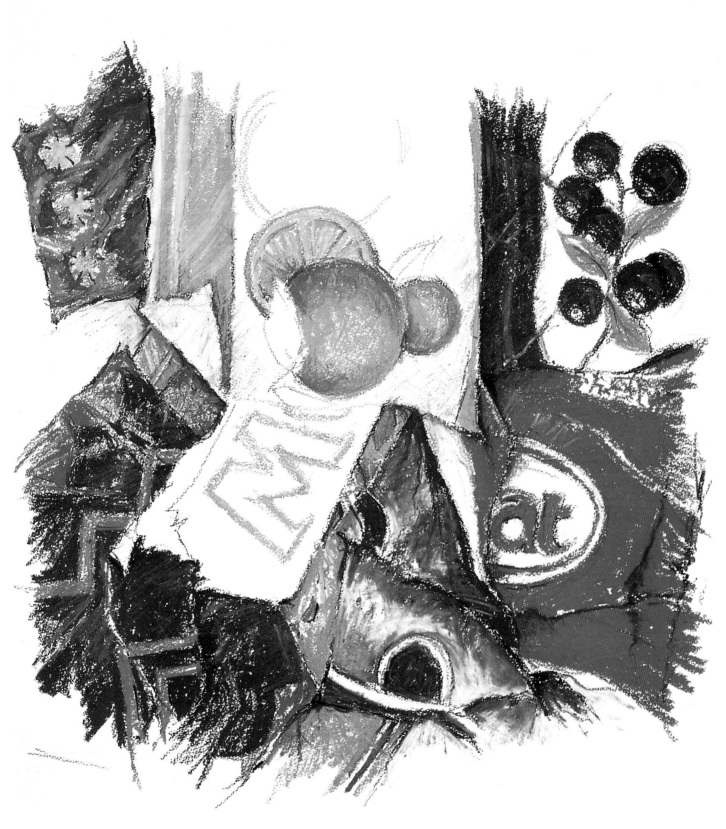

**10** I had known from the beginning that any solid area of black would dominate the composition. While the black wrapper is not in the geometric centre of the composition, it is visually central. For this reason, I left this section until the very end so that I could judge the inter-relationship of the other colours more easily.

# Mark Making

## Oil Pastels

You can create a wide variety of tones and textures by applying oil pastels in different ways.

*Create highlights by rapidly dragging a white oil pastel across the base colour*

*Use the texture of the paper to create highlights: less pressure allows the paper to show through*

*Produce tones of colour by drawing onto the lighter colour with a darker version; for example, orange and red, or light blue and dark blue*

*You can make very deep tones by blending a colour with black*

## The finished drawing

*Vigorously applied colour; sharp angles created by the very positive application of black pastel (contrasted with sharp lines of white); and unfinished edges that lead the viewer's eye into the centre of the composition combine to produce a drawing that sizzles with energy.*

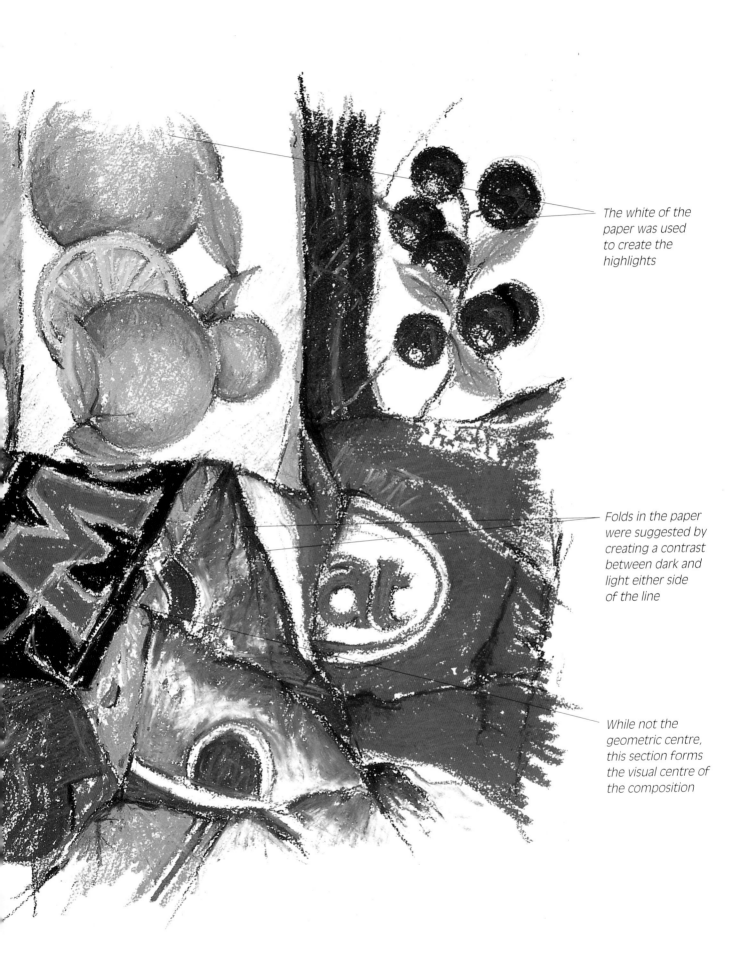

The white of the paper was used to create the highlights

Folds in the paper were suggested by creating a contrast between dark and light either side of the line

While not the geometric centre, this section forms the visual centre of the composition

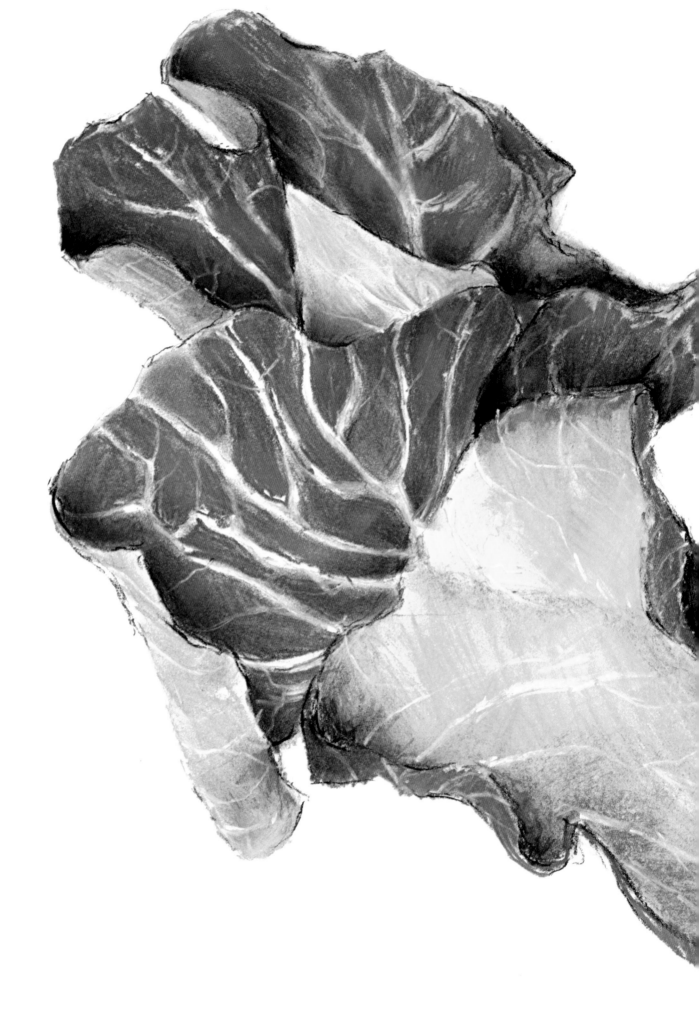

# DIRECT DRAWING

This chapter focuses on using the observation skills considered in Chapter 1, and combining these with the energetic approach outlined in Chapter 2. The result is 'direct drawing' – reacting immediately to your subject, without fear or hesitation, and without being too concerned about creating a realistic interpretation. Truly creative drawing does not necessarily mean copying what is in front of us. Instead, we can use our subjects as a starting-point to create original drawings that have a life of their own.

Direct drawing sometimes owes more to the materials and how you use them than to the original subject; the materials may dictate how you record a particular subject and determine the marks you make.

**Imaginative shapes**
*The shape of this cabbage leaf viewed in isolation, bears little resemblance to its origins as part of a large vegetable. But this is part of the appeal of direct drawing. The original subject is not the most important factor.*

# Drawing onto canvas

Canvas is a highly textured surface that is challenging to draw on: the uneven threads that run across its surface can disrupt the flow of a line drawn with any medium, creating breaks and jumps that may introduce unexpected elements into your drawings.

## A challenging surface

*This oil pastel drawing of a pumpkin shows how challenging canvas can be as a drawing surface. The marks made need to be confident and vigorous or the oil will not take to the surface. Much of the canvas can be seen showing through the picture. This can be useful for a very high-key drawing – one in which all the tones are very light, although not necessarily white.*

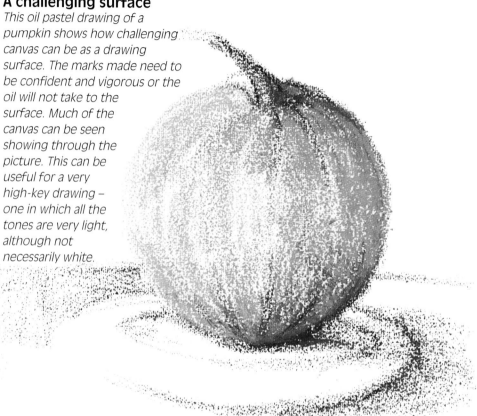

## Emphasizing texture

*You can emphasize the highly textured quality of canvas by drawing with the side of an oil pastel. While the tip of the pastel gives slightly more clarity and definition, it still leaves only a little deposit of colour on this surface.*

*Mark made with side of oil pastel*

*Mark made with tip of oil pastel*

## Blending on canvas

*Oil pastels can be difficult to blend on this surface because of the limited amount of colour that rests on the canvas.*

## Practice Exercise

This still-life set-up, drawn directly onto canvas using oil bars, provided a wonderfully tactile experience as the sticks of solidified oil paint glided across the rough canvas.

**1** First, using a confident sweeping motion, draw the outline of the objects using the appropriate colours. Then start to block in the main colours, following the lines of the subjects' shapes. The drawing will look quite flat at this stage.

**2** Next, choose the darker colour for each object. Here, the base colour for the pumpkin was orange, and the darker colour red. The base colour for the marrow was yellow, and the darker colour green. Begin to blend these by drawing with the darker colour into the wet base colour, working the dark oil bar over the light one.

**3** Finally, add a neutral shadow colour (that is, a colour that you have not yet used) to help give the composition a more unified and harmonious feel. Drag the colour across the canvas to achieve a lighter tone, and work over the oil bar drawing to achieve a much darker colour.

The texture of
the exposed
canvas acts as
a highlight

The linear qualities
of the subject are
picked out in charcoal

### The finished drawing
*The oily nature of the media used allowed a spontaneous approach to the drawing. The thickness of the oil bars meant that colour became the prime concern, as creating detail was not really an option.*

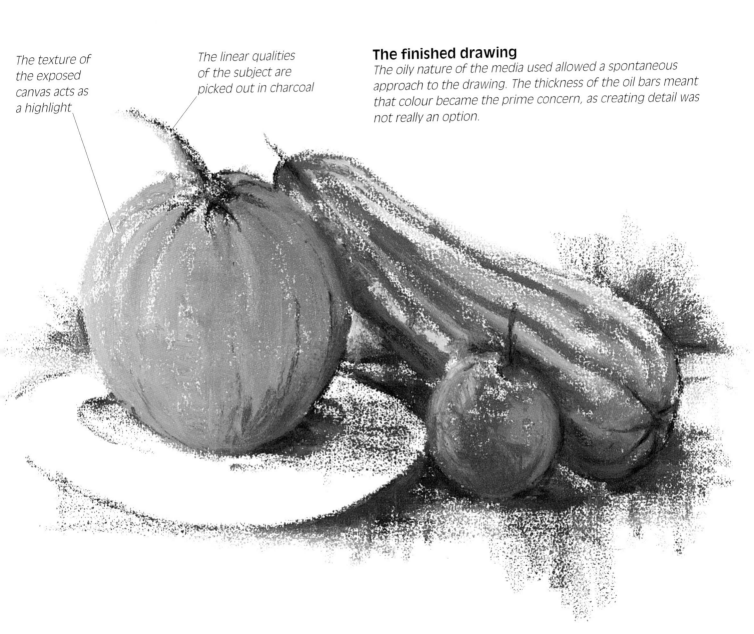

### Applying colour on canvas
*Because of the viscosity of oil bars, much more colour remains on the canvas surface. You can fill an area quickly with the edge of an oil bar, while drawing with the tip produces a stronger, sharper line.*

*Mark made with edge of oil bar*

*Mark made with tip of oil bar*

### Blending colour on canvas
*The soft quality of oil bars allows colours to be blended very effectively on a canvas surface.*

# Direct drawing

Direct drawing is about responding immediately and instinctively to the shapes and colours that you see, rather than creating a studied, photographic likeness of your subject. Before you start on a drawing of this nature, clear your head of preconceived notions about your subject and how to record it. Instead, tap in to your individual response to the subject by asking yourself what you find exciting about it. Is it the colours? The shapes? The textures or the patterns? Once you have identified the key element, concentrate on finding the best way to convey it. Try to remember the following points:

- Respond directly to the colours – don't try to build up tones.

- Use vigorous marks and make each one count.

- Don't be afraid of using pure, unblended colour.

- Make any blending a quick, physical process, using your fingers if necessary.

## Mark Making
### Creating Tones with Oil Bars

You can blend oil bars either by working one oil bar over another, or by using your fingers to 'feel' the merging of the colours. Oil bars are particularly useful for direct drawing, as you can achieve  thick textural qualities with only a few quick marks. Their purity of colour also allows you to respond instantly, thereby capturing the dynamics of your subject.

## Cross-Section

The near-abstract quality of this cross-section makes it ideal for a direct drawing. You can concentrate on recording pure shape, colour and tone without trying to create an over-realistic or laboured representation of the subject. I used long strokes to record the linear qualities, short stabbing marks to emphasize the texture, and physical blending to create the variety of tones.

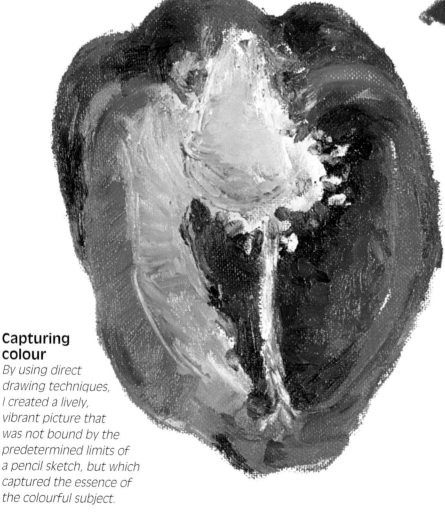

**Capturing colour**
*By using direct drawing techniques, I created a lively, vibrant picture that was not bound by the predetermined limits of a pencil sketch, but which captured the essence of the colourful subject.*

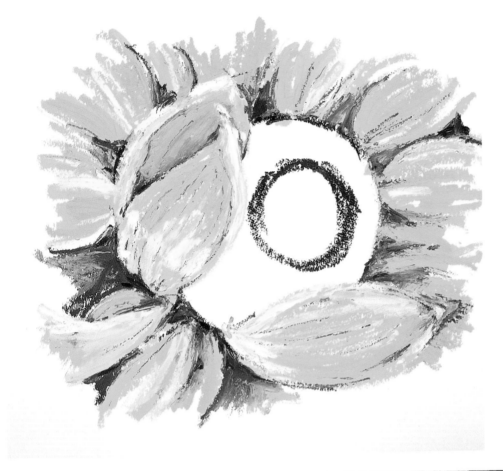

**6** I stepped back and assessed what I had done so far. All of the marks had been made by long and sweeping or short and linear movements to recreate the soft, shiny petals. However, the inner sections of the flower head, which held the seeds, required a very different treatment.

**7** I created the inner section by roughly cross-hatching with a brown oil bar. This allowed the texture of the surface to show through.

**8** I picked out the highlights at the centre by cross-hatching, but used a sharper style to avoid any blending of colours – the yellow needed to stand out in its own right. I also applied a few dots and dabs of pure red as these helped to 'lift' the yellow, forcing it to stand out even more.

**9** The drawing was reaching its final stages and, once again, I stepped back and assessed the image. Although I was pleased with the overall appearance, I felt that I had not fully captured the brilliant colour of the flowers.

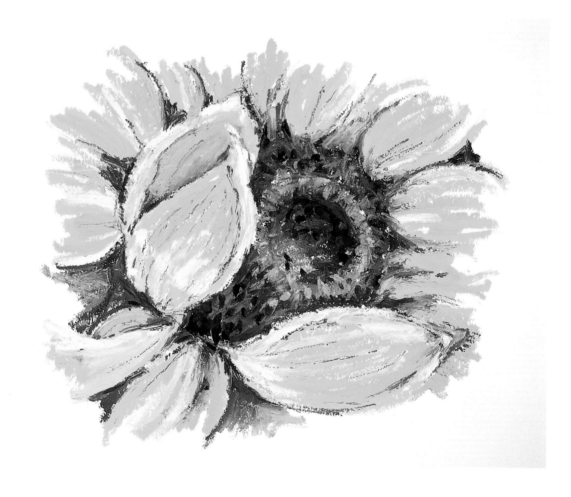

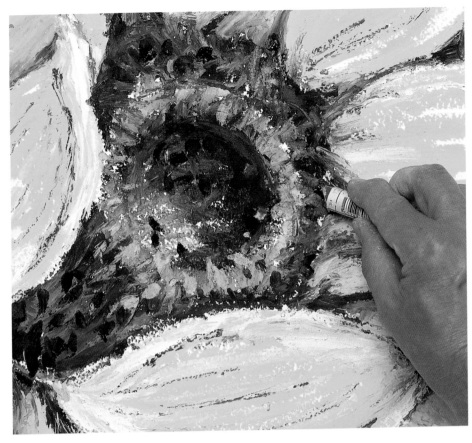

**10** I therefore introduced more bright red, even though no pure red existed within the actual flower head, because I knew that a little red, being close to both brown and yellow, would push the yellow forward and make the brown appear darker.

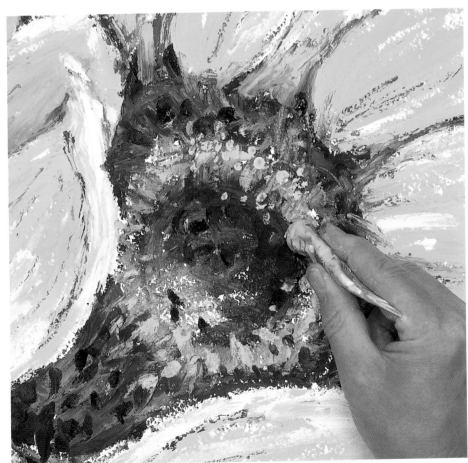

**11** To give this drawing some physical texture, I applied a few final highlights using oil paint squeezed directly from the tube to represent some of the lighter-toned seed heads.

The softness of blended oil bars contrasts well with the hard edges made by unblended oil bars

The three-dimensional element created a central area of interest as well as a tactile part of the drawing

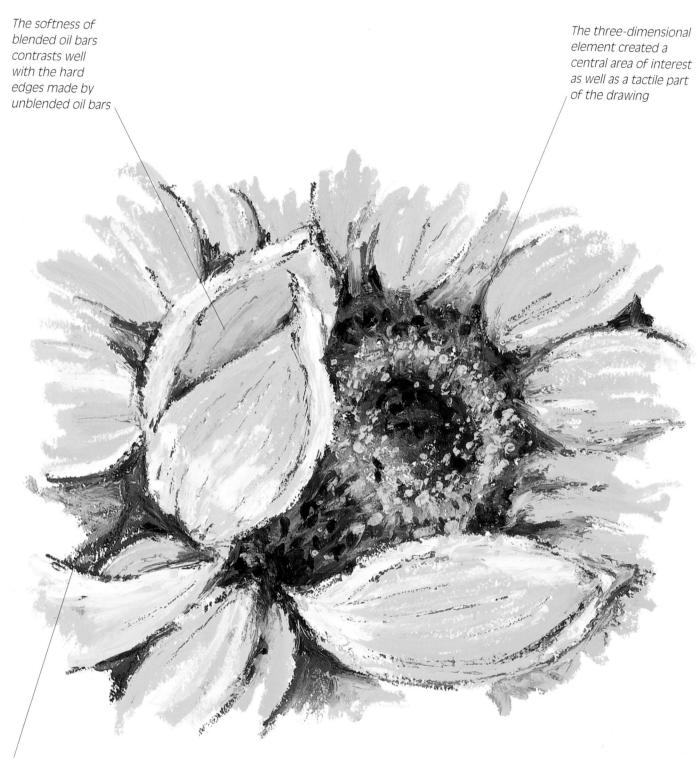

The lack of refinement in the application of colour gives this drawing much character

### The finished drawing
*The finished picture was lively and relied on a variety of mark-making techniques. The use of simple colours helped create a clean, uncluttered drawing that holds the warm colours of a long summer's day.*

# Mark Making
## Oil Bars

The combination of these materials creates many possibilities for texture and tonal blending.

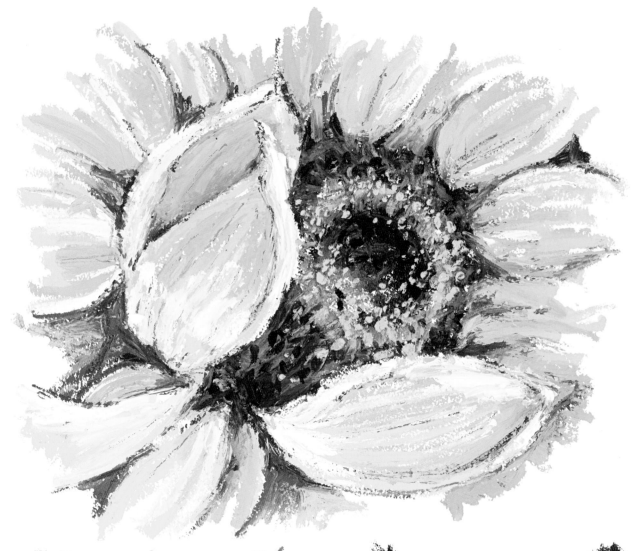

*Varying the pressure of an oil bar on canvas creates a variety of tones*

*A few quick marks can create partial blending*

*Extended blending can create very soft sections of tone*

*Cross-hatching is effective with oil bars on canvas*

*One-off applications of red help to liven up the picture*

*Paint squeezed directly onto the canvas adds an extra textural element*

# The physicality of blending

Sometimes you need to take a particularly physical approach to blending your media – for example, by using a cloth. Oil-based media are ideal for this technique, as they soften quickly when solvents are applied. Because of this, you must work rapidly and vigorously before your underdrawing begins to dry.

## Practice Exercise

This exercise involves laying two colours next to each other, then producing marks by blending them with solvent. The texture of the spirit-soaked cloth helps to create marks as it is dragged across the rough canvas surface. The marks made by using this process are lively and energetic, and give a particularly loose feel to the image created.

**1** Make a quick drawing of your subject using a 6B or 8B pencil (anything harder will not be effective on canvas).

**2** Roughly block in the shapes of the leaves by laying flat blocks of yellow and green oil bars next to each other. This process should take only a few minutes.

**3** Next, soak a textured piece of cloth in a solvent appropriate for oil-based drawing sticks – turpentine or white spirit are recommended. Then, before the solvent dries or evaporates, vigorously rub the cloth across the two colours – speed helps to achieve a drawing that looks fresh and unlaboured. Be sure to move the rag in the directions that you wish your marks to go.

**4** You will be left with a very loose drawing with soft edges. You will find that the rag has a residue of oil colour on it. If you create an edge or point from the rag, you can draw some feathered lines or sharpen up a few loose ends.

**5** To complete the drawing, you can add a few lines with an oil pastel to act as visual punctuation marks, but be sparing. The drawing is almost complete, and overworking it will negate the freshness and spontaneity of the solvent marks.

## Mark Making
### Blending Oil-Based Media

You can draw with a solvent-soaked cloth, using it to blend or smudge the oil-based material.

*Two pure colours laid next to each other without blending*

*Solvent-soaked cloth used to blend colours*

*Cloth with colour residue can be used to create feathery shapes*

*Addition of lines can aid direction and suggest more clearly defined shapes*

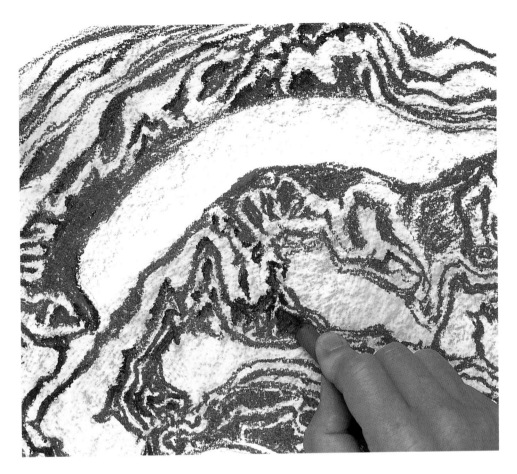

**10** Oil pastels are so thick that they can be difficult to blend easily in small spaces, but I needed to blend the dark blue lines softly into the purple areas in some parts. To achieve this, I worked onto the blue pastel with a red pastel, pulling the oil pastel down onto the purple base.

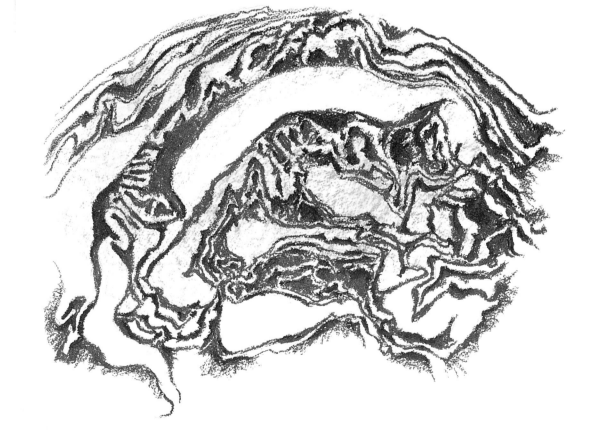

**11** Once again, I stood back to assess the colours and tonal values. During the drawing process I had created a wide range of tones, but had eliminated all the highlights.

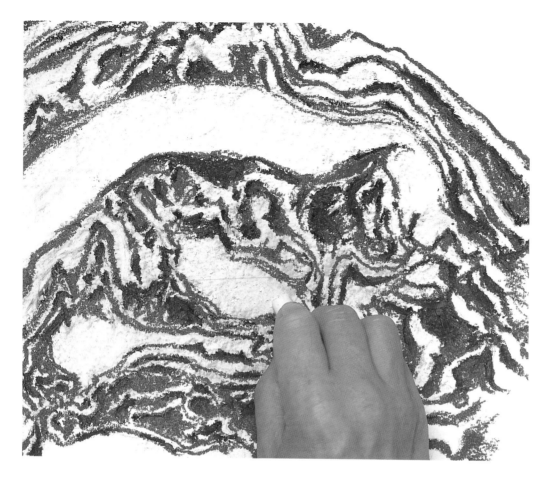

**12** I used a white pastel to pick out a few flashes of pure white, which gave the picture a little sparkle.

# Mark Making

## Oil Pastels

You do not need to use a large number of colours to create a wealth of tones – just a few will do.

*Red pastel and purple pastel used as base colours*

*Blue pastel used to darken red pastel*

*Wavy, one-stroke lines used in cabbage*

*Blue pastel drawn in lines to create hard-edged shadows*

*Edge of pastel rubbed over with solvent-soaked rag*

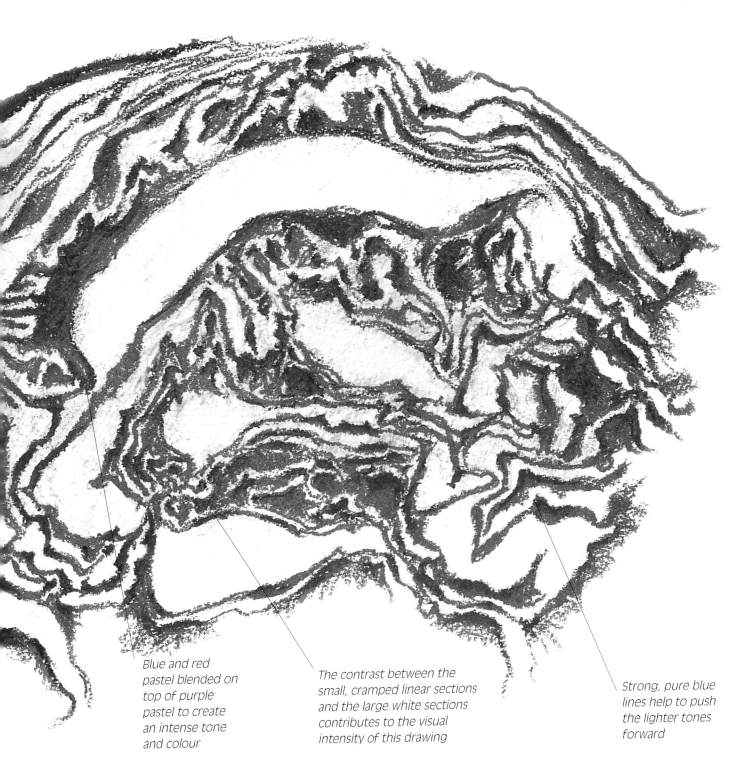

Blue and red
pastel blended on
top of purple
pastel to create
an intense tone
and colour

The contrast between the
small, cramped linear sections
and the large white sections
contributes to the visual
intensity of this drawing

Strong, pure blue
lines help to push
the lighter tones
forward

## The finished drawing
*This drawing has a number of abstract
qualities – shapes that are not instantly
recognizable as tangible objects, and
no specific cut-off areas where the
drawing actually ends. It is a drawing
that had a clear starting point but
developed a life of its own.*

# Unusual viewpoints

Your drawings will be more interesting if you take an innovative approach to your subject. Even everyday objects such as kitchen utensils or garage tools, which may be uninspiring from our normal viewpoint, become far more inspiring if you look at them from an unusual angle.

**Unconventional viewpoint**
*Wherever you are, try to look at everyday objects, tools and utensils from different angles. Looking directly down onto this wine-bottle top, I noticed a wealth of interesting tones and shapes that might have gone unobserved had I taken a more conventional viewpoint.*

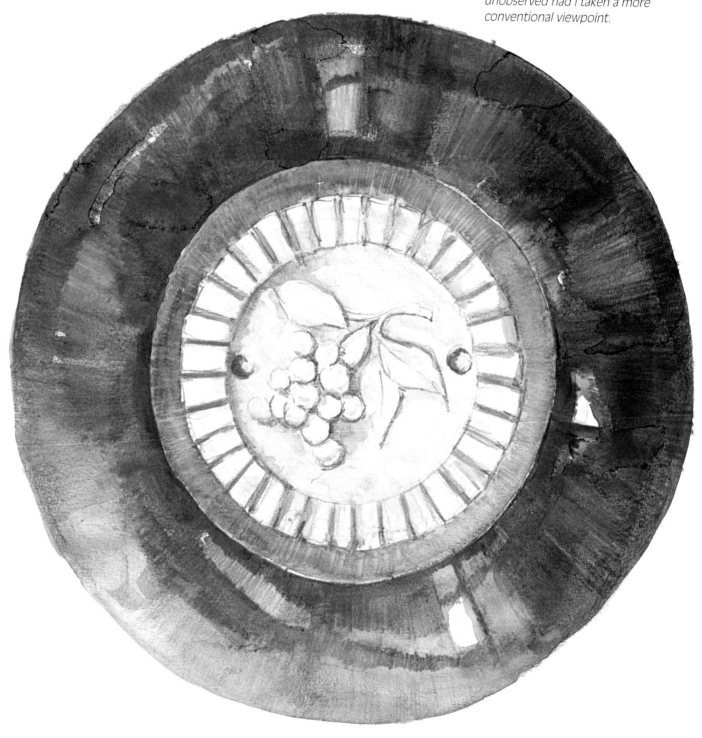

## Practice Exercise

Choose an everyday household object (I selected an old iron) and make three direct drawings, changing your viewpoint each time. This allows you to observe aspects of your subject that you might not have noticed before – not only its unusual appearance when considered from a different viewpoint, but also the way in which light reflects from its surfaces at different angles.

**1** The first drawing was completed from a normal viewpoint, taking a slightly angled view from a relatively high position. This results in an interesting yet predictable drawing because we see the object as we would usually view it.

**2** This was more challenging to draw, as the handle sloped up and away from my viewpoint. The shading, shadows and reflections, however, became more interesting. The curves and streaks of white caused by the reflections and distortions of the strip lights on the ceiling provided an exciting set of shapes to record.

**3** This viewpoint resulted in a more flattened-out view, but offered a satisfyingly solid shape to record. Much of the intricacy of detail was hidden or eliminated. The simple, dynamic shape required a different approach from the previous drawing, with much more solid marks, and more areas blocked in.

# Drawing positions

Most of the exercises so far have involved you either sitting or standing to create a drawing. This exercise examines some alternatives. You can find remarkable and inspiring views of everyday objects if you lie or crouch on the floor and look up, or if you lean as far as you dare out of a window and look down.

Unlike the exercises on pages 108–9, it is not so easy to choose the angle of the object that you are going to draw: you have to respond directly to the object you see from the position you are in.

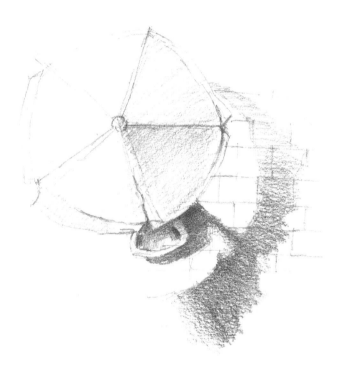

**Aerial view**
*The aerial view that was taken to create this drawing involved leaning over a balcony and looking directly down onto the scene below. The objects take on a different form from how we usually view them: they are reduced to simple flat shapes and patterns.*

## Practice Exercise
We don't usually see a standard lamp as two concentric circles, one slightly off-centre, but if you look up along the stand and through the shade your perception of the lamp changes dramatically.

**1** First, lie on your back, looking upwards into a standard lamp. This is not an easy position in which to draw, but it can be achieved if you use a 6B or 8B pencil, as you do not have to press too hard to make a mark on your paper. Quickly draw the shapes that you see.

**2** Having done the line drawing, you can move to a more comfortable position and work on your picture from memory. You can, of course, resume your position to remind yourself of the shapes and tones of the subject.

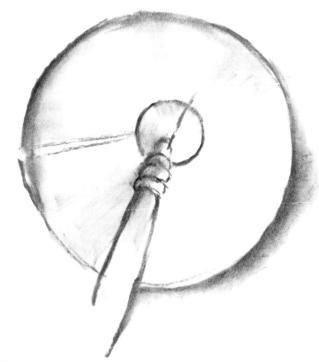

**3** Strengthen your initial drawing with a stick of charcoal. Spray it with fixative to prevent it from smudging as you carry on working on top of it.

**4** Now work onto the drawing using charcoal and graphite powder to create a range of tones. Fill in the set of near-abstract shapes, remembering that you can make your drawing as abstract as you wish.

## The finished drawing
*The near-abstract qualities of this drawing were developed by creative use of the materials and by taking a highly visual viewpoint. More importantly, the drawing was started with no preconception about its eventual outcome.*

*The sense of design created within this drawing is partly a result of the lack of finish. This type of drawing need not be contained within a predefined rectangle*

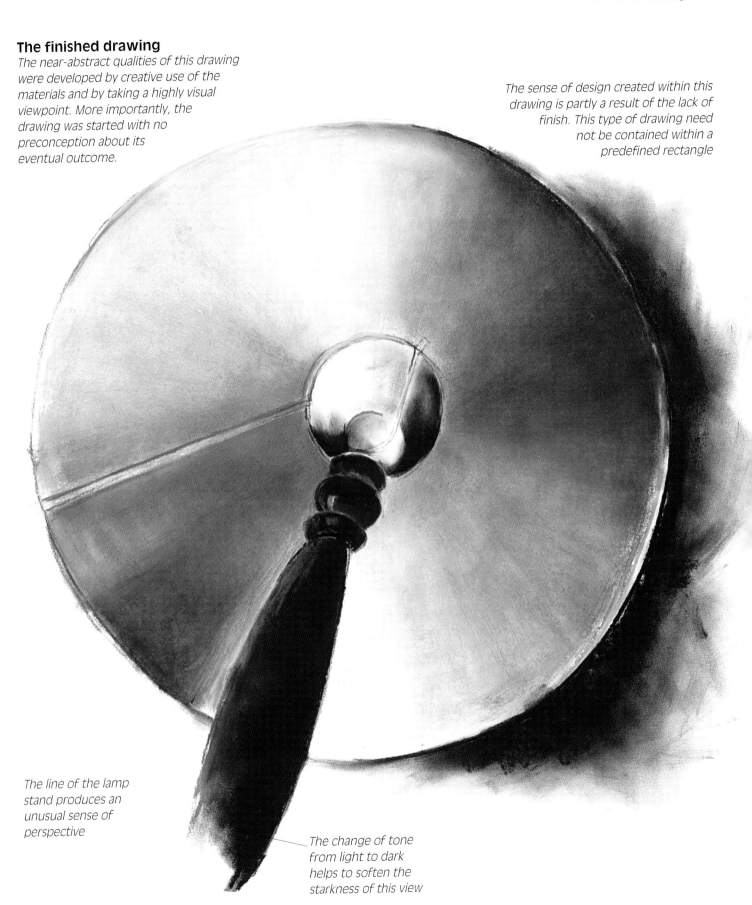

*The line of the lamp stand produces an unusual sense of perspective*

*The change of tone from light to dark helps to soften the starkness of this view*

# Abandoning perspective

For centuries, when setting up a still-life group or composing a landscape painting, artists would focus on a single viewpoint and draw or paint from that one spot. This convention was challenged at the turn of the 20th century, when artists such as Pablo Picasso and Georges Braque experimented by abandoning the traditional single viewpoint and subsequent perspective, and created pictures that included more than one view of their subject. These experiments produced images that were considerably flattened. As there was no real impression of perspective, the images took on a greater sense of design and pattern.

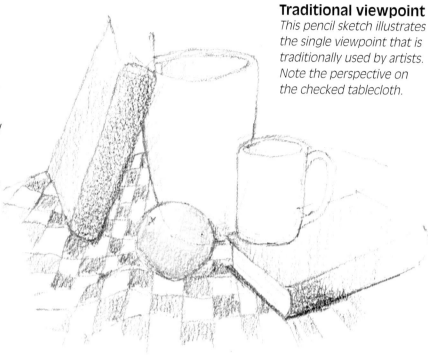

**Traditional viewpoint**
*This pencil sketch illustrates the single viewpoint that is traditionally used by artists. Note the perspective on the checked tablecloth.*

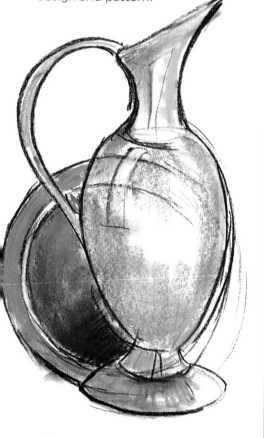

**Visual contradiction**
*When you see two objects together, try to imagine how they would look if you altered the perspective of one object but left the other as you actually see it. The result will be a visual contradiction, like this plate and vase, but one that is decorative and appealing.*

## Practice Exercise

Water-soluble pencils are ideal for this type of drawing, as they allow lines and colours to flow into each other, avoiding the creation of clear-cut shapes.

**1** First, make a drawing of the aerial view of the tablecloth. Looking down upon it eliminates any sense of perspective. Draw the checked cloth as a flat backdrop against which the subjects of the still-life group will be viewed.

**2** Now draw the group of objects set on top of the backdrop. Because the image is flattened by the background, the scene becomes less representational and more abstract. The sense of perspective also becomes less important.

**3** To enhance the decorative aspect of this drawing, fill in the colours, using some of the initial drawing guidelines. This gives some parts of the drawing a transparent look, again helping to eliminate the sense of perspective.

**4** Finally, wash over the coloured pencil loosely with a wet brush. This reconstitutes the water-based pigment and gives the effect of a watercolour wash. Before the paper dries, reinforce some of the lines by drawing onto the damp paper with a water-soluble pencil. This gives a rich, thick line, enhancing the shapes previously drawn.

## The finished drawing

*The looseness of this picture is a result of washing water freely over the water-soluble pencils. Making a more accurate attempt to fill in the shapes would have been out of keeping with the aim of the exercise, which was all about changing our normal concept of shape and form.*

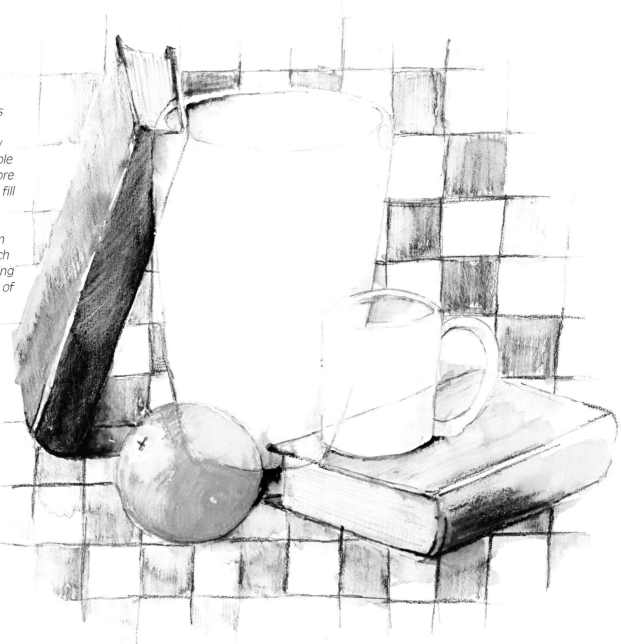

# Mark Making
## Water-Soluble Pencils

Water-soluble pencils are a versatile medium that you can use to create lines and soft bleeds.

*A wash across a drawn line does not eliminate the line completely, but softens it so it looks like watercolour paint*

*Colours can be blended using water as the medium*

*Drawing onto damp paper creates a rich, thick line that bleeds outwards*

# Drawing from multiple viewpoints

This demonstration is based loosely upon the concepts of Cubism. The artists of this early 20th-century art movement started by viewing objects as geometric forms and ended with multiple viewpoints and fragmented images. The drawing featured here is viewed from three separate viewpoints that are superimposed upon each other to create a single complex and highly fragmented composition.

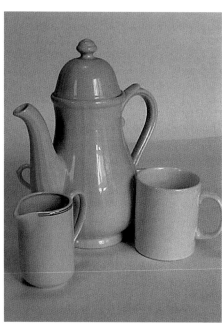

**Starting point**
*I selected a group of white objects for this drawing. This removed the distraction of colour, allowing me to concentrate on shape and form.*

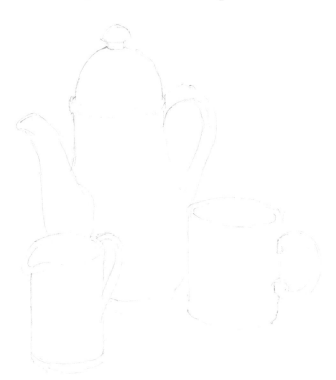

**1** Working onto a large sheet of strong, heavyweight drawing paper, I made an initial line drawing from my chosen starting point. There was no particular reason for starting here, because I was intending to include all views in the final composition.

**2** I then moved to another position, giving me a different view of the group. I drew that view on top of my previous drawing, superimposing the two images.

**3** I found a third viewpoint by again moving around the table upon which the group was positioned.

**4** When I had drawn the group from this viewpoint, superimposing another view on the developing drawing, the result was a complex, fragmented pencil drawing.

**5** The next stage was to introduce an element of pattern by strengthening the pencil drawing. I did this by overworking it with charcoal. This removed some of the subtlety of the pencil marks and provided a harsher and sharper linear structure.

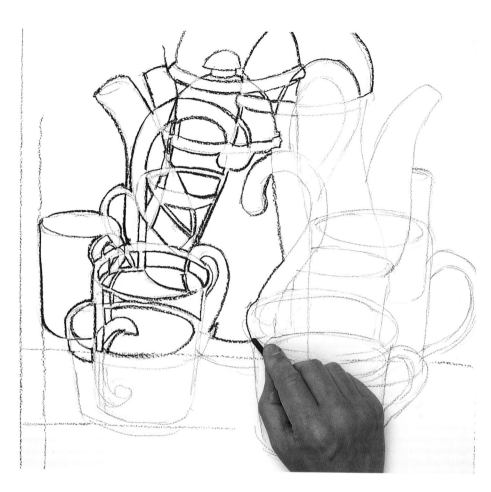

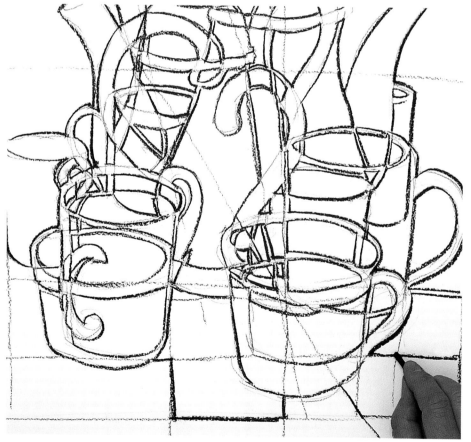

**6** Once I had drawn the main group, I then looked for new structures that had developed within the solid charcoal image. I found many lines that I could extend diagonally, vertically or horizontally, and these added considerably to the emerging abstract nature of the drawing. The completed drawing owed as much to the patterns and designs within it as it did to its original starting point as a simple still-life group.

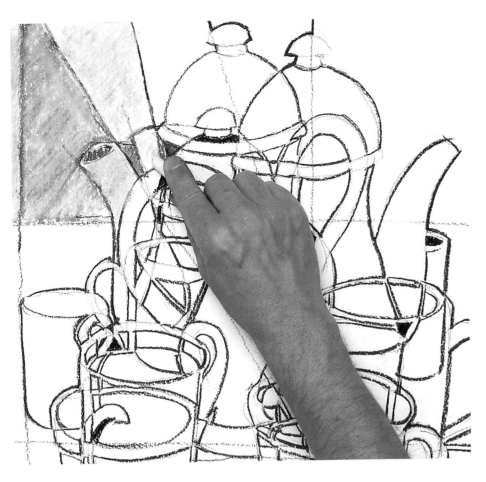

**7** For practical purposes, I began to work down from the top of the composition. Soft pastels smudge easily, so it is best not to have to rest or lean on sections of a drawing already completed. I decided to work in tones of violet to imbue the hard-edged design with warmth and subtlety. I began blocking in the shapes created by extending structure lines with a range of tones.

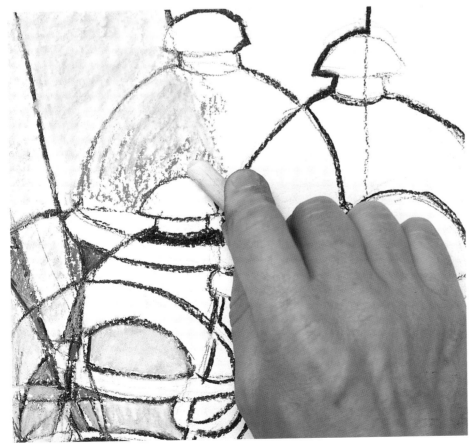

**8** As I was working with only four pastels, I needed to blend the tones on the paper. I used a mid-violet pastel initially to fill in the shapes between the lines of the charcoal drawing. I then worked over these shapes with a white pastel to lighten the tone.

**9** I continued this process across the paper. I filled the spaces with colours and tones that would strengthen the sense of abstract design. I tried to avoid placing similar tones next to each other. So as to enhance the visual dynamics of the composition, I filled in a few small sections in pure charcoal black. This helped to push some of the lighter colours forward.

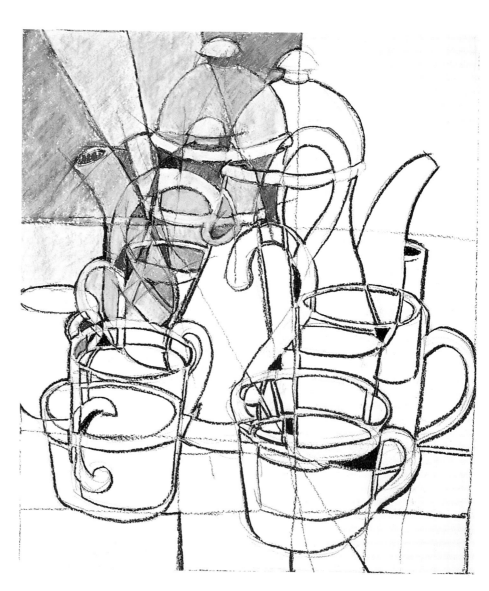

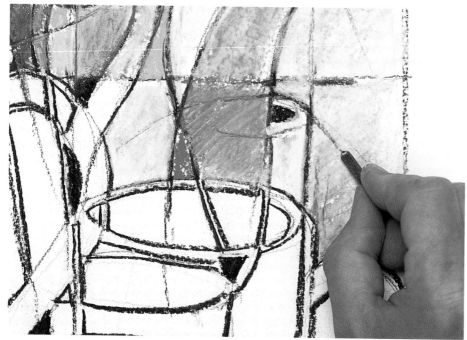

**10** As I filled in more sections, I noticed more lines that could contribute to the final outcome by being extended into the coloured drawing. I used a thin piece of charcoal, making soft, gentle marks to act as a contrast with the hard edges of the initial line drawing.

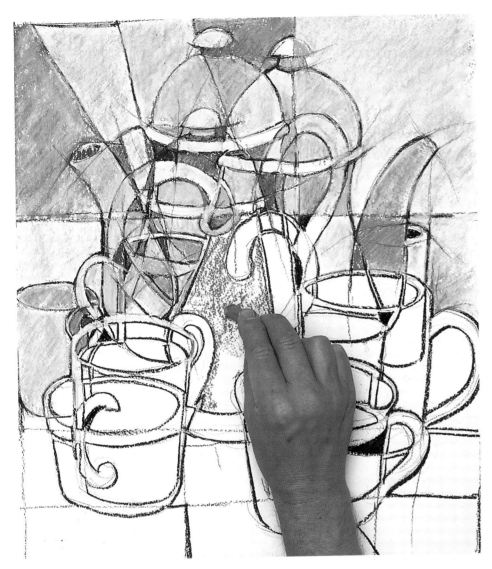

**11** I blocked in some of the larger spaces using the side or edge of the pastel. This involved pulling and dragging the pastel around the inside of the shapes concerned to establish the base tone, and then working over this with another pastel to create the desired colour.

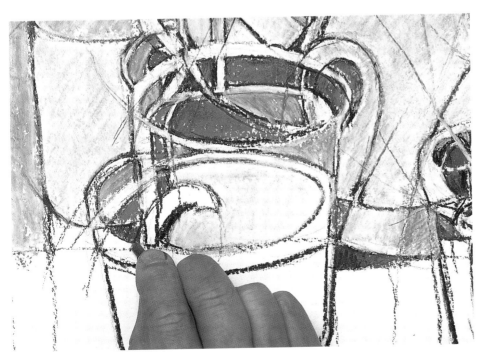

**12** I enhanced the visual dynamics further by contrasting the large areas of open colour with the small sections of enclosed shapes. I looked for areas where I could impose a new, more intense set of lines upon the drawing: this helped to create a new set of shapes that required filling with colour and tone.

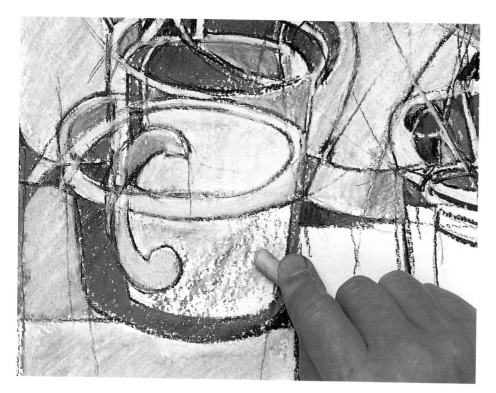

**13** As the drawing began to reach its completion, I found it more challenging to maintain a variety of tones and to assess the tonal values of shapes. To address this problem, I used the powder produced by soft pastels. The harder the pastel is pressed onto the paper, the more powder is produced. Therefore, I varied the pressure on the pastels and created more or less powder accordingly. This helped to moderate the tones as more or less of the paper showed through the pastel covering.

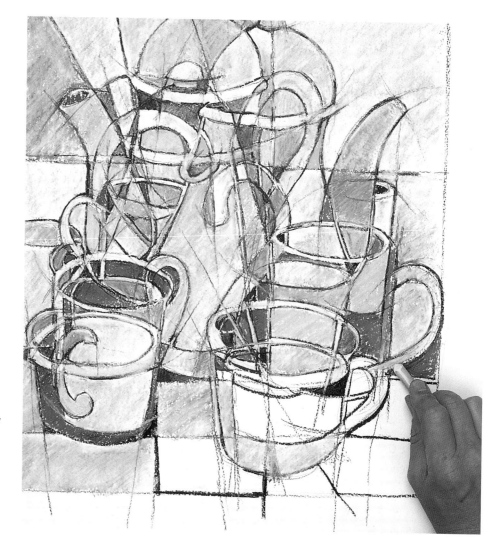

**14** I continued the process across the bottom right of the drawing, creating dark sections with a lot of pressure to contrast with the light sections, where I barely skimmed the pastel across the paper. I created some of the darkest sections by establishing a charcoal base and then drawing over this with a mid-tone violet pastel.

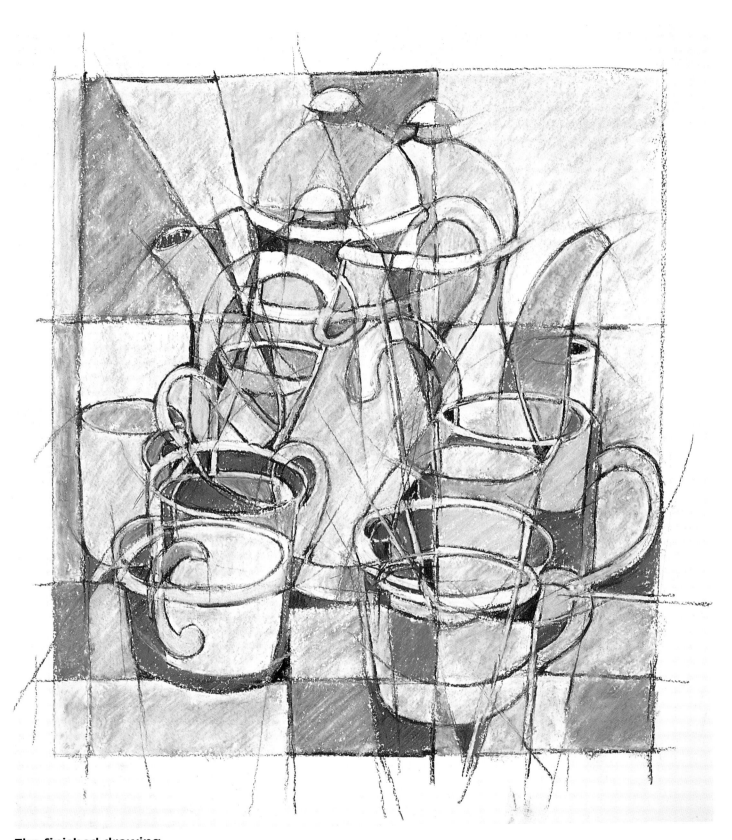

## The finished drawing
*The completed drawing is a mixture of hard and soft lines; some establishing the strength of the drawing, and others only hinting at a more 'internal' set of structures. The drawing contains a mixture of light and dark tones, some competing for visual dominance, others receding, and compelling viewers to look deeper into the composition to discern the shapes of the fragmented images.*

## Next Steps

The drawing was now abstract, and had a character of its own. However, I felt that it could be developed further still. I wanted to experiment with some of the techniques outlined earlier in this book. What would happen if I worked on another type of surface? How about extending the drawing outside the traditional rectangle? The notion of collage was appealing, and I decided to introduce a different texture to the drawing to help expand it physically and develop it further artistically.

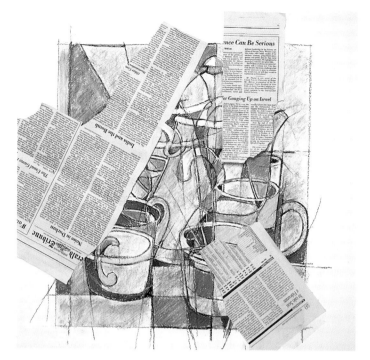

**1** I decided to take the drawing a stage further. So I experimented by tearing up a few sheets of newspaper and positioning them along some of the construction lines.

**2** I extended the shapes from the completed drawing onto the newspaper using charcoal. The feel of the drawing changed greatly as the charcoal stick slid freely across the smooth newsprint. As the newspaper was only attached lightly at the edges, I could lift the paper to get a clearer view of the drawing underneath.

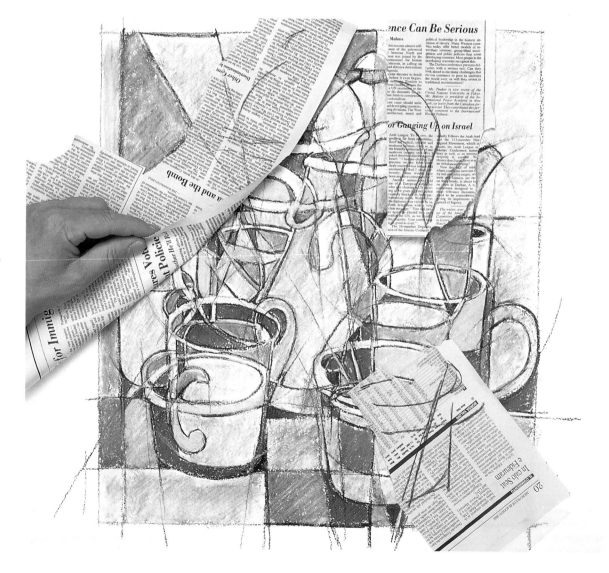

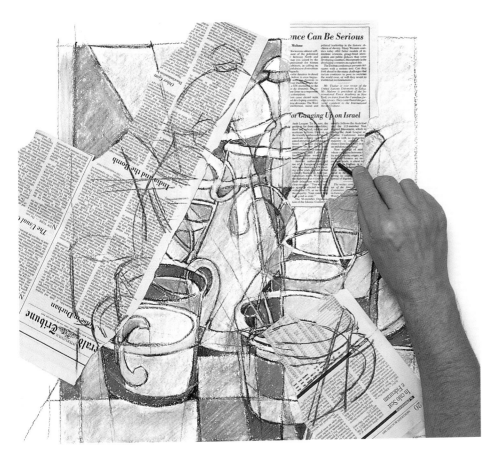

**3** Once I had completed the charcoal drawing, I began to apply colour. I knew this would be much more challenging than applying pastel to drawing paper, because newsprint has no 'tooth' to hold the pastel, and because the black print would affect the colour.

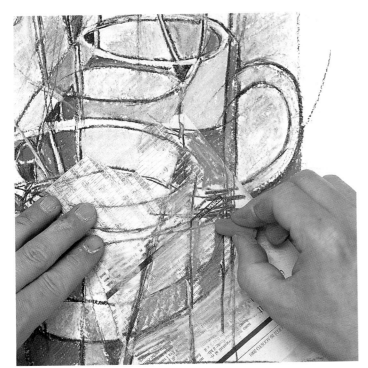

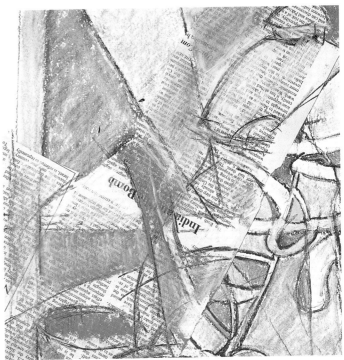

**4** I discovered that the print on the paper added to the variety of tone. By blocking in using the edge of the pastel, I applied only a loose covering of powder to the newspaper. The print that showed through added a new dimension to the tonal qualities of the drawing.

**5** I decided to allow some of the newspaper headlines to show through the pastel covering. Although black, and therefore visually compatible with the linear drawing, the introduction of text to aid the structure of the finished piece provided a very unusual aspect to the work.

# Mark Making

## Soft Pastels

Soft pastels can be used to create a variety of tones on a wide range of surfaces.

Edge of
pastel mark

Solid area of
pastel powder
created by
drawing with
the tip

Hard charcoal
marks to
define the
key shapes.

Softer lines
created by
sketching
lightly onto
pastel marks

Pastel used
on its side
allows text to
show clearly
(above left)

Even using
the pastel tip,
the underlying
grey tone of
the text is
still evident
(above right)

## The finished drawing

The finished drawing is a mix of hard and soft lines, with a new texture imposed upon it. The colours are limited but the tones extensive. This drawing has incorporated a number of the approaches considered throughout this book: it is experimental in both approach and use of materials. I was satisfied both with the end result, and the innovative processes with which it was created.

The bold text
adds an extra
dimension to
this picture

The soft extension
lines of the subjects
contrast with the
strong structural
charcoal marks

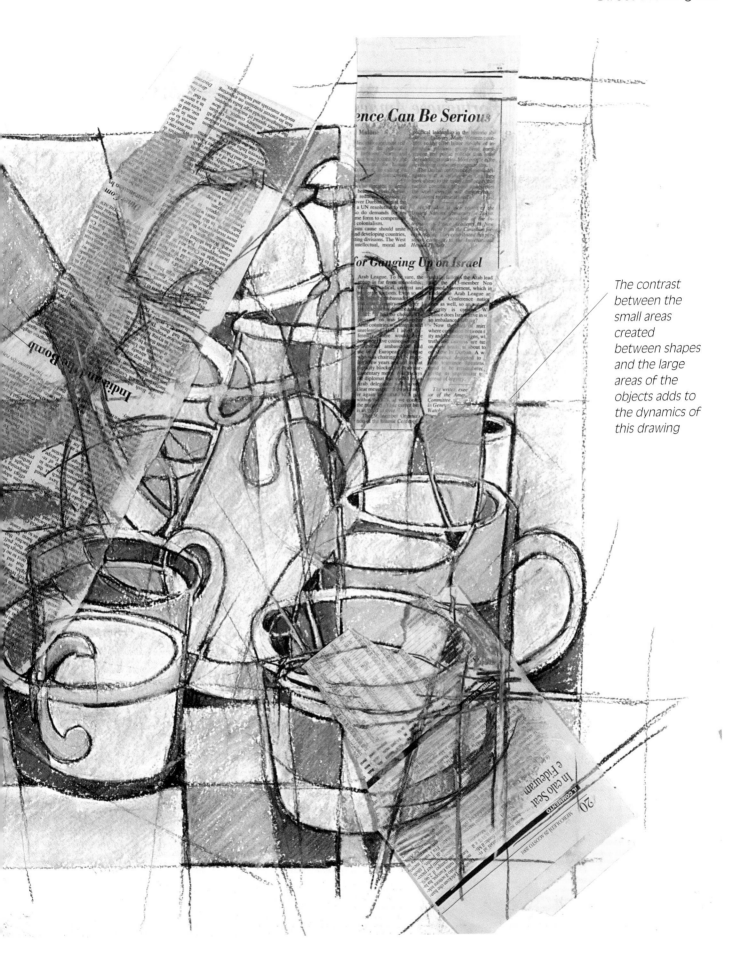

*The contrast between the small areas created between shapes and the large areas of the objects adds to the dynamics of this drawing*

# Final thoughts

My philosophy from the beginning of this book has been to encourage you to 'have a go'. Hopefully, by now you will have tried many of the projects and the extension exercises, and are looking at the world around you in a very different way. Once you are tuned in to visually assessing your everyday surroundings for potential drawing subjects, they take on a whole new meaning. A shopping basket is no longer just a bundle of groceries and bottles to be put away, but a cornucopia of exciting colours and shapes. You will see cabbage leaves as intricate designs, cheeses as hard-edged shadows, and tomatoes and lettuce as vibrant complementary colours. Your entire way of seeing may be irrevocably affected.

You will see drawing as having many facets. A drawing may be a small linear sketch to trace a series of interesting lines, or a large, expansive and expressive response to an exciting shape. These types of drawing have very different requirements. The former needs a small sketchpad and no space at all, whereas the latter requires a room where you can leave your work on an easel, on the wall, or even on the floor for a time. All this presents most of us with some logistical problems – what happens when the children arrive home from school or the family pet decides to investigate your work? These factors need not be restrictions to your working on a larger scale – just something to consider.

## Working Safely

While few people would consider drawing to be a hazardous activity, there are a couple of issues worth considering, if only for your own comfort when working. The drawing materials considered in the book are non-toxic – manufacturers of art materials have to meet the demands of commercial rules and regulations. I do, however, advise the use of fixative sprays and solvents, and these have the potential to cause some discomfort if used carelessly. Both of these can emit strong odours, and should only be used in well ventilated areas.

## Conclusion

The potential for creative drawing exists everywhere – you just need to grab the opportunities as often as you can. Continue to practise, and to experiment and push back as many boundaries as you dare.

# Glossary

**Canvas paper** Textured painting or drawing paper with a grained surface that mimics canvas.

**Charcoal** Traditionally made from willow, this is carbonized wood, now produced in commercial ovens.

**Conté crayons** Coloured chalks that range from black to white, or warm rich reds and browns.

**Dip pens** Traditional mapping pens with detachable nibs that are ideal for dipping into ink for line drawing.

**Fibre-tip pens** Commercially produced pens with nylon nibs that usually contain water-based ink.

**Fixative spray** Colourless solution, sold in aerosol dispensers, which protects powder-based pictures.

**Graphite powder** A form of natural carbon, available in tubs or jars. It is a very fine powder with a smooth feel.

**Inks** Soluble dyes that are usually transparent. They are frequently permanent and rarely water-soluble.

**Oil bars** Pigments blended with linseed oil and mixed with wax, making them more buttery than oil pastels.

**Oil pastels** Pastels made by binding pigment with wax and oils. These can be diluted with white spirit or turpentine.

**Pigment** The raw material, often derived from natural substances, from which coloured media are made.

**Putty rubber** Kneadable erasers that remove graphite from paper without marking the paper's surface.

**Soft pastels** Made by binding dry pigment together with a gum solution. The texture of these is often crumbly and powdery.

**Torchon (or stump)** A tightly rolled piece of paper used for blending powdery media.

**Watercolour paper** Made from cotton fibres, these are strong, durable papers that come in a variety of sizes and weights.

**Water-soluble pencils** Pencils that contain pigment bound in soluble gum Arabic. They can be used as dry drawing pencils, or washed over with water to create watercolour-style marks.

# Index